WATERCOLOR BASICS: PAINTING FROM PHOTOGRAPHS

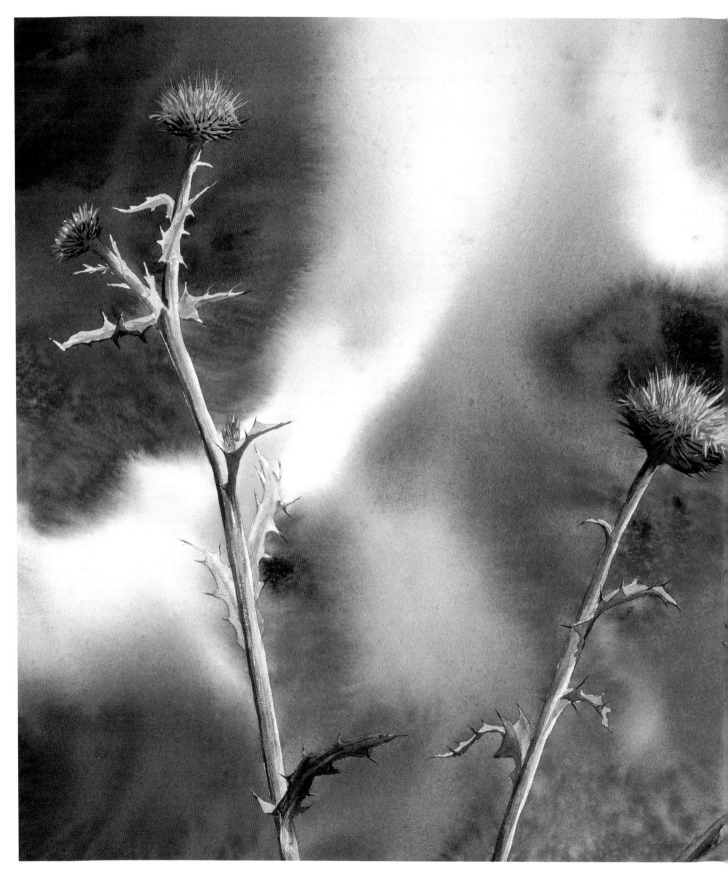

Thistles
Watercolor
12″ × 16″ (30cm × 41cm)

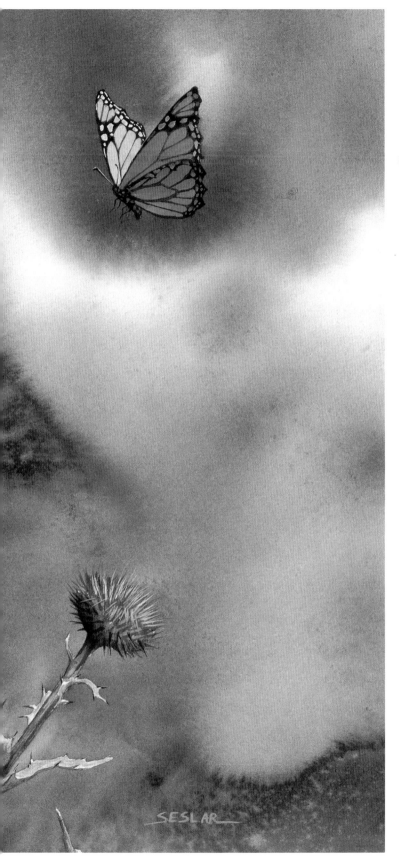

Watercolor Basics: Painting From Photographs

PATRICK SESLAR

NORTH LIGHT BOOKS
CINCINNATI, OHIO

ABOUT THE AUTHOR

A graduate of Purdue University, Patrick Seslar has served as a contributing editor for *The Artist's Magazine* since 1986. In that time, he has written more than seventy articles on art technique and marketing.

He is the author of *Wildlife Painting Step by Step* and coauthor (with Robert Reynolds) of *Painting Nature's Peaceful Places*, both from North Light Books.

He is also an accomplished artist. His life and work are profiled along with those of twenty other artists in the North Light collection *Being an Artist*. His paintings have been exhibited in galleries across the country and have appeared in numerous national magazines and newspapers, including *The Artist's Magazine*, *Trailer Life*, the *Los Angeles Times* and the *Miami Herald*.

He and his wife, Lin, divide their time between La Jolla, California and Sebring, Florida.

Library of Congress Cataloging-in-Publication Data

Seslar, Patrick
 Watercolor basics. Painting from photographs / by Patrick Seslar.—1st ed.
 p. cm.
 Includes index.
 ISBN 0-89134-893-X (pbk. : alk. paper)
 1. Watercolor painting—Technique. 2. Painting from photographs. I. Title.
ND2422.S48 1999
751.42′2—dc21 98-50538
 CIP

Editor: Glenn Marcum
Production editor: Nicole R. Klungle
Cover designer: Angela Lennert Wilcox and Wendy Dunning
Production coordinator: Kristen D. Heller

DEDICATION

To my father, who inspired me to write.

ACKNOWLEDGMENTS

A special thanks to my editors at North Light Books: Rachel Wolf and Glenn Marcum, and to my wife, Lin, for the many illustrations she contributed as well as for her tireless patience in reading over the rough drafts as this book took shape.

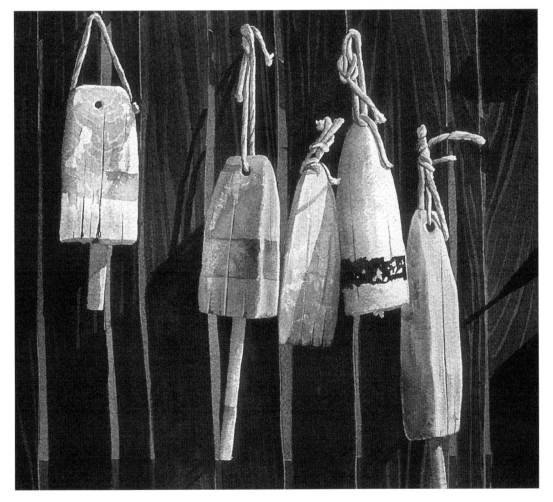

Where the Buoys Are
Watercolor
10" × 14" (25cm × 36cm)

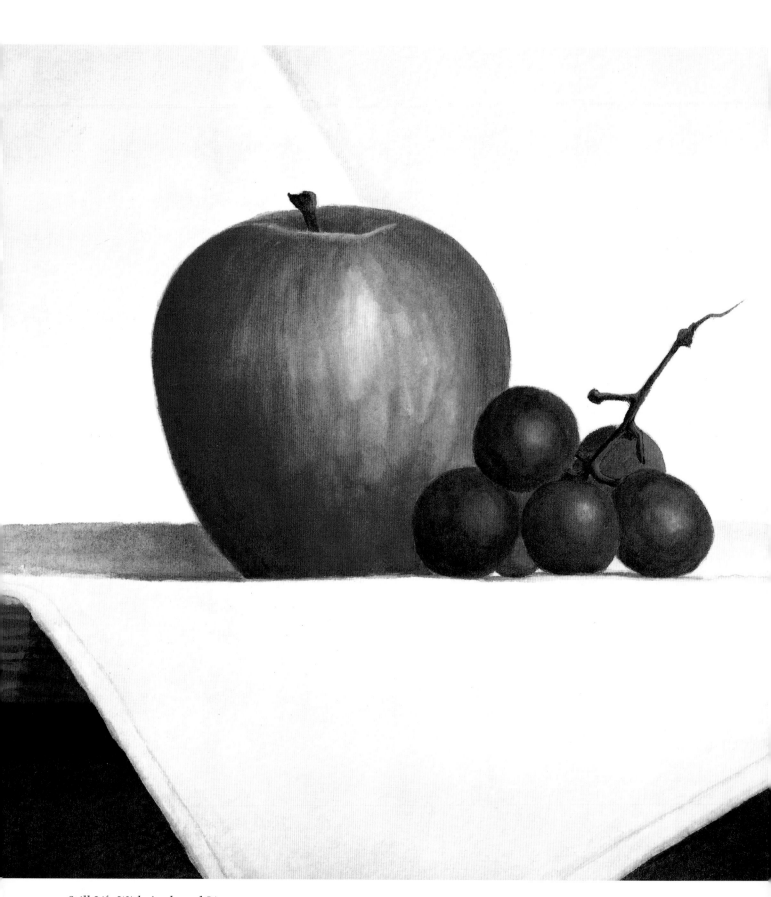

Still Life With Apple and Linen
Watercolor
7½″ × 10″ (19cm × 25cm)

CONTENTS

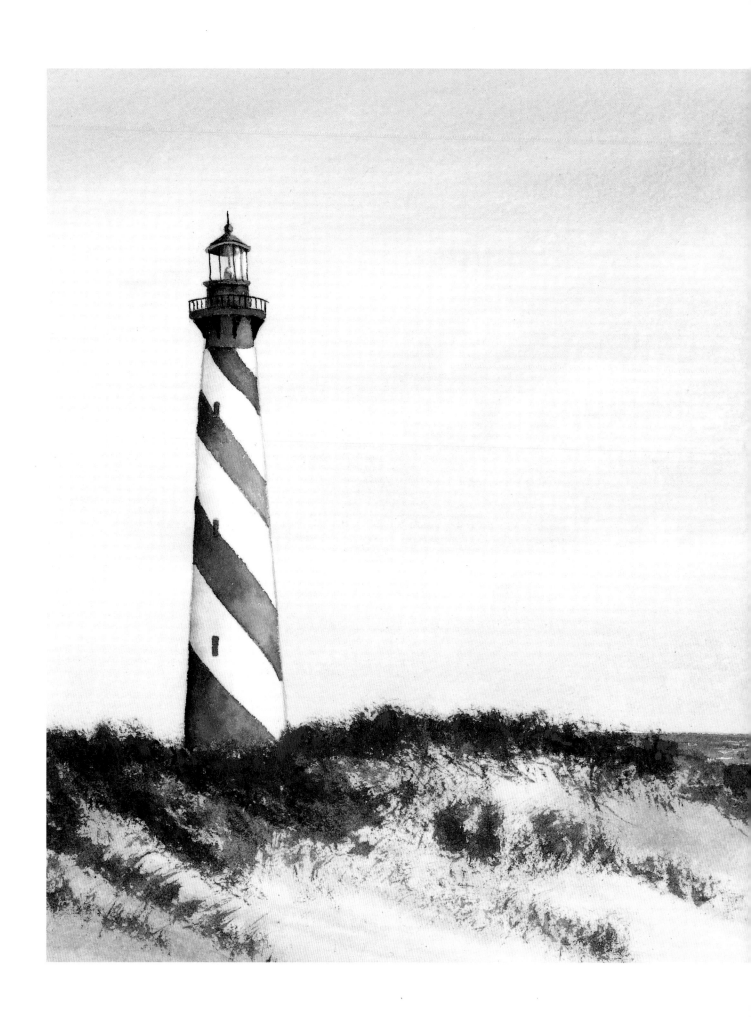

INTRODUCTION

If you've ever taken a photograph and said, "Now that would make a great painting!" you were probably right. Of course, if you're like most artists, you may have hesitated to follow your instinct because you were afraid using photographs was somehow cheating or not being creative. The truth, however, is that when you paint from photographs, you are in esteemed company. Many great artists, including Edgar Degas and Thomas Eakins, used photographs in creating their art. Without Eadweard Muybridge's pioneering stop-action photographs, artists would probably still be painting running horses in improbable postures that would make the hunchback of Notre Dame look like a prima ballerina.

So follow your instinct, and remember that photographs are a great learning tool as long as you understand their strengths and weaknesses. In the pages that follow, you'll learn how to assemble a photographic sketchbook as well as how to find or create good compositions. Armed with that knowledge, you'll discover a variety of ways to simplify and transform promising photographs into great watercolor paintings. Let's get started!

Cape Hatteras Light
Lin Seslar
Watercolor
8" × 16" (20cm × 41cm)

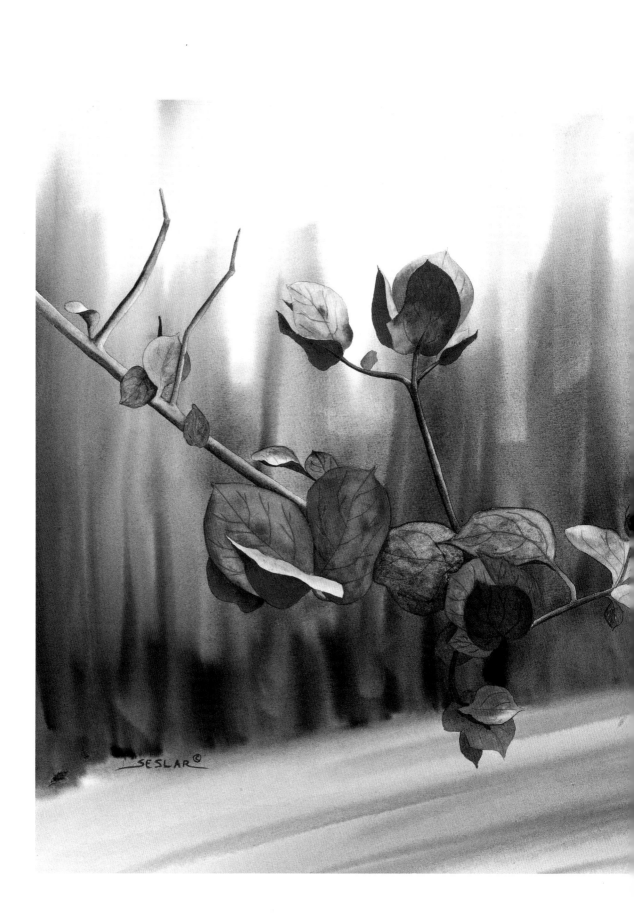

GETTING STARTED

Where to begin? At the beginning, of course. If you've been waiting to start painting because you don't know much about watercolor, or because you want your drawings to look more like Rembrandt's than Picasso's, this chapter will get you off to a solid start.

In the pages that follow, you'll discover that you need only a few basic brushes, a sheet or two of watercolor paper, a favorite photograph and a willingness to go for it. You'll find valuable tips on getting the most for your money when buying brushes and colors. You'll learn what your choices are when it comes to cameras, lenses and film. You'll also learn some simple photographic "tricks of the trade" to help you take better reference photographs. All of this information will make the process of creating paintings from your favorite snapshots easier and more enjoyable.

Bougainvillea
Watercolor
12″ × 16″ (30cm × 41cm)

Watercolor Supplies

If you want to begin simply, it only takes a small investment to get started painting terrific watercolors from your favorite snapshots. A basic studio setup includes five brushes, a sheet of watercolor paper and a couple of tubes of color such as Burnt Sienna (warm) and Ultramarine Blue (cool). To take advantage of a broader palette and to create certain special effects, you can add as many colors as you like, along with some or all of the useful accessories described in this section.

Brushes

Your selection of brushes depends on your painting style—a loose, impressionistic painting might be handled easily with a single 1-inch (2.5cm) flat, while a more detailed rendering may require four or five different brushes. In general, use as few brushes as possible and get to know them well. Every brush has a distinct personality, even though it may be otherwise identical to other brushes of the same size and brand. Learn how much water or pigment each brush holds, and for how long. Get to know how the brush hairs behave when pinched between your thumb and forefinger, splayed against your palette or shaped to a point.

Bargain brushes are seldom ideal, yet you needn't reach for the most expensive brushes either. Synthetic sables are reasonably priced and perform well, particularly in larger sizes. Where fine detail is necessary, you'll get better results with red sable brushes.

Here's a good basic selection of brushes:

1-Inch (2.5cm) Flat. Any good synthetic sable or red sable brush will do. A 1-inch (2.5cm) brush is particularly handy for prewetting paper, for wet-in-wet effects (such as soft backgrounds) and for laying down smooth graded washes (such as in skies).

No. 8 Round. Again, a synthetic will do. This brush has a good point and carries lots of paint. Use it for laying down heavier lines, such as tree trunks, and for creating graded tones in confined areas like flower petals. When squeezed between the thumb and forefinger, the hairs form a narrow shape that produces a fine line when used on edge

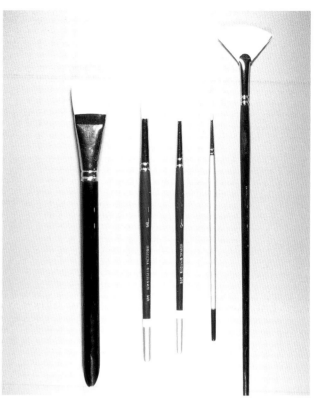

FIVE BASIC BRUSHES
From left to right: 1-inch (2.5cm) flat, no. 8 and no. 4 rounds, no. 1 liner, no. 1 bristle fan.

and excellent drybrush effects when used broadside.

No. 4 Round. A smaller version of the no. 8 round, the no. 4 round is an excellent choice for detailed work such as branches, flower stems and drybrush textures.

No. 1 Liner. This brush has a fine point and hairs twice as long as a standard brush. You'll find it indispensable for anything requiring delicate lines, such as grass and twigs. Buy a red sable—it holds a point better than synthetic.

No. 1 Bristle Fan. This is a useful brush for textural effects such as grasses and foliage. Different brands vary widely in stiffness and bristle length and produce varying effects.

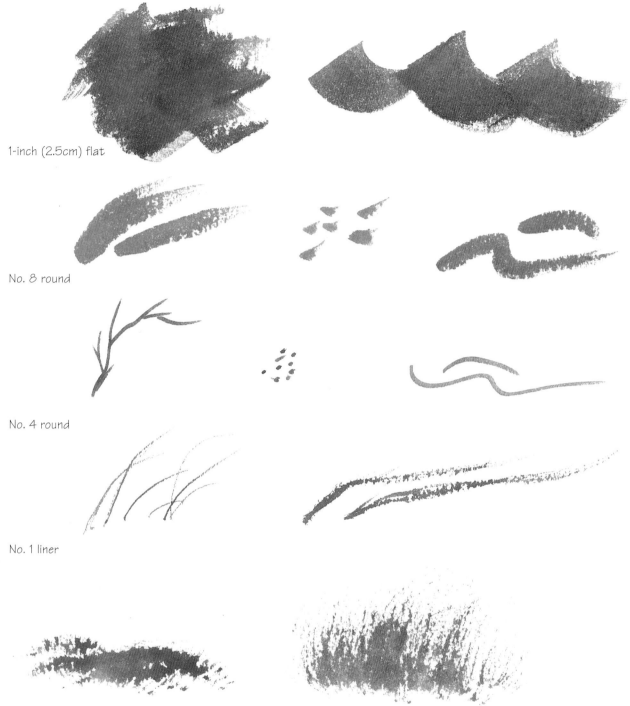

1-inch (2.5cm) flat

No. 8 round

No. 4 round

No. 1 liner

No. 1 bristle fan

Experiment with each of the five basic brushes to see what kinds of strokes are possible. Try holding each brush at different angles or varying the pressure to explore different effects.

Paper

A good watercolor paper should be durable and take paint well. It should withstand repeated scrubbings with a bristle brush, an eraser, a paper towel or the blade of a painting knife. A good paper should allow you to remove dried masking fluid without damaging its surface. It should also produce evenly graded washes and soft transitions between colors when working wet-in-wet.

Bargain papers are seldom a good choice. Quality papers are generally more economical in the long run because they produce better results and less frustration. Most quality paper brands produce fine results but, in my experience, Arches papers provide the best combination of durability and performance.

Watercolor papers are available in a variety of sheet sizes up to 22″×30″ (56cm×76cm), as well as in wider rolls. Another popular format is called a "block"—ten to twenty-five sheets of watercolor paper and a heavy chipboard backing glued around the edges. This eliminates the need for stretching and taping the paper on a drawing board. Blocks come in a variety of sizes from 7″×10″ to 18″×24″ (18cm×25cm to 46cm×61cm).

Paper Finishes. Watercolor papers come in three finishes: rough, cold-pressed, and hot-pressed. Each manufacturer's version of these finishes produces different results. For most applications, however, a cold-pressed surface provides the best all-around balance for both detail and loose brushwork.

Weight. The weight of watercolor paper provides a general idea of its thickness. For small images— 12″×16″ (30cm×41cm) or less—use 140-lb. (300gsm) paper. You needn't stretch if you tape the edges down with masking tape or use a watercolor block. For larger images, use 300-lb. (638gsm) paper (which feels more like cardboard). Normally, 300-lb. (638gsm) paper doesn't need to be stretched, and often the edges need not be taped. Another alternative is watercolor board. Although typically only 90-lb. (190gsm) stock, the paper is permanently mounted to a heavy backing board that eliminates buckling and makes individual panels easy to handle and cut to size with a utility knife.

THREE TYPES OF PAPER
On rough paper (left), the texture remains visible. This pattern can be used when painting rocks, rough bark or any subject best expressed with broken color. Cold-pressed paper (center), has a less pronounced texture. It's an ideal surface because it allows you to create subtle areas of broken color yet still render sharp detail where desired. A hot-pressed paper (right) has little texture. Color goes down evenly, undisturbed by the paper's surface. Hot-pressed is great for sharp detail, but broken color effects are more difficult and color may lift when you'd least like it to.

Colors

Believe it or not, you *can* have too much of a good thing—especially colors. If you're new to watercolor, you might start simply with two colors—Burnt Sienna (warm) and Ultramarine Blue (cool). You'll be surprised at the variety of warm and cool tones you can create from only two colors.

As your familiarity and confidence grow, you'll want to add Phthalo Blue, Phthalo Green, Sap Green, Yellow Ochre, Cadmium Yellow Pale, Alizarin Crimson and Cadmium Red Pale. The palette shown contains these plus eight optional colors: Cerulean Blue, Cadmium Orange, Burnt Umber, Warm Sepia, Raw Umber, Raw Sienna, New Gamboge and Cadmium Yellow Deep. Although this is not the ultimate palette, many subtle variations of each color are possible. Experiment to choose those that best suit your personality and style. The colors used in this book are from Winsor & Newton or Grumbacher.

Palettes

A good watercolor palette should have plenty of wells for fresh tube colors and a large central area for premixing large washes. Most palettes are white plastic like the one pictured. They're inexpensive but quickly become stained with color. Because of this, many watercolorists prefer to use a white enamelled butcher's tray.

Pure Ultramarine Blue

Pure Ultramarine Blue and Burnt Sienna

Pure Burnt Sienna

Mostly Ultramarine Blue with some Burnt Sienna

Approximately equal parts Ultramarine Blue and Burnt Sienna

Mostly Burnt Sienna with some Ultramarine Blue

Above mixture with more water

Above mixture with more water

Above mixture with more water

A few examples of the variety of color mixtures available from only two colors—Burnt Sienna and Ultramarine Blue.

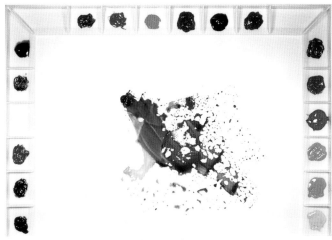

PALETTE COLOR ARRANGEMENT
Left side (top to bottom): Sap Green, Phthalo Green, Cerulean Blue, Ultramarine Blue, Phthalo Blue. Top row (left to right): Alizarin Crimson, Cadmium Red Pale, Cadmium Orange, Burnt Umber, Warm Sepia, Burnt Sienna. Right side (top to bottom): Raw Umber, Raw Sienna, Yellow Ochre, New Gamboge, Cadmium Yellow Deep, Cadmium Yellow Pale.

Useful Accessories

Masking Fluid (Liquid Frisket). Painting around things is tedious and time-consuming. With frisket you can be fearless. Gray masking fluid is less distracting than the neon pink variety and has always seemed easier to remove.

Masking Tape. Although hardly revolutionary, ¾" (1.9cm) masking tape saves precious time. By taping 140-lb. (300gsm) or 300-lb. (638gsm) paper to a hardboard panel, you can avoid the entire process of soaking and stretching. Masking tape is also excellent for removing dried frisket.

Watercolor Paper in Blocks. A popular watercolor paper format is the block, which consists of ten to twenty-five sheets of paper and a heavy chipboard backing glued around the edges. These glued edges eliminate the need for stretching and taping the paper to a drawing board. Blocks come in a variety of sizes from 7"×10" to 18"×24" (18cm×25cm to 46cm×61cm). Having several different size blocks handy can also save time; a 10"×14" (25cm×36cm) sheet mats up to a 16"×20" (41cm×51cm) frame and a 12"×16" (30cm×41cm) sheet frames to 18"×24" (46cm×61cm) with no cutting and no waste!

Hair Dryer. This tool is another great time-saver. When using liquid frisket, the paper must be bone dry to avoid damaging the surface when the masking is removed. Likewise, when overlaying one wash of color over a previous wash, the paper must be thoroughly dry to prevent lifting the previous color. A hair dryer vastly shortens the drying period and helps keep spontaneity and enthusiasm at its peak.

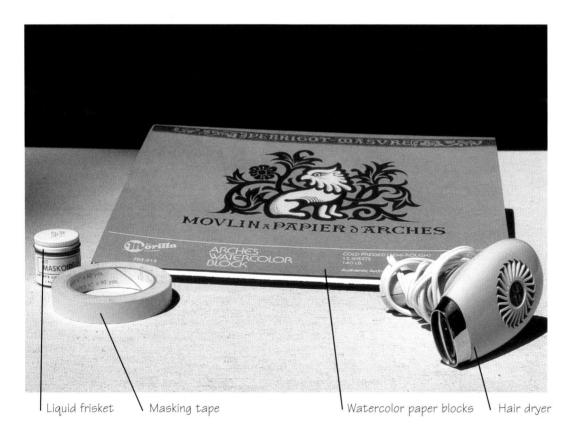

Liquid frisket Masking tape Watercolor paper blocks Hair dryer

Other Useful Items
Here are additional items you'll find helpful:

Sponges. Keep an assortment of natural and synthetic sponges handy for quickly creating textures such as foliage and gravel.

Table Salt. Keep a shaker nearby. It's effective for producing interesting textures—and for tossing over your shoulder for better luck when a painting isn't going well.

Paper Towels. Keep a roll on hand for sopping up excess water when prewetting paper for wet-in-wet techniques. It's also useful for blotting brushes during drybrush techniques.

Painting Knife. Great when used on its edge for scraping thin lines, like veins in leaves, or when used broadside to create thicker grasses.

Spray Bottle. Get the kind of bottle that glass cleaner comes in and fill it with clean water. Use it to speed the prewetting of paper and for creating subtle textures.

Eraser. Get the softest eraser possible, either kneaded or one of the white varieties like Eberhard-Faber's Magic Rub, so you don't damage the paper surface when correcting preliminary drawings.

Cameras and Film

Any camera will suffice for collecting snapshots and reference photographs, so don't hesitate because you aren't sure your camera or photographs are good enough. Snapshots are only a starting point—it's what you do with your paints and brushes that matters. If you already own a camera, great! You probably have a stack of promising reference material to get you started. On the other hand, if you don't own a camera yet, take heart—you don't need to spend a fortune or become a photomaniac to get the reference snapshots you need. Here are a few pointers that should help you make a good selection.

Single-Use Cameras

Single-use cameras are readily available and cost only slightly more than film and developing alone. Standard and panorama print formats are available, and for a little more you can get an underwater camera. Because the components are inexpensive, the focus won't be as sharp as in more expensive cameras, but the prints are still adequate for painting reference.

Point-and-Shoot Cameras

"Point-and-shoot" cameras range in price from slightly more than single-use cameras to as much as a good 35mm model. Quality point-and-shoot cameras have better lenses and produce sharper images than single-use cameras. Equally important, both print and slide films are available, as are faster (more light-sensitive) films for low-light situations. Many point-and-shoot cameras offer features such as telephoto lenses, autofocus and automatic film loading, winding and rewinding.

Advanced Photo System Cameras

Advanced photo system (APS) cameras are a hybrid between point-and-shoot and 35mm cameras. Prices are similar to those of point-and-shoot cameras, and many "auto" features are available. More expensive APS models offer through-the-lens viewing like traditional 35mm cameras. APS cameras allow users to select one of three print formats (see next page) and to see the image in the viewfinder in the chosen format. APS processing is more expensive, and no slide films are currently offered.

35mm Single-Lens Reflex Cameras

35mm single-lens reflex (SLR) cameras offer a full range of automated features and two additional advantages: (1) viewing is through the lens, so "what you see is what you get"; and (2) lenses can be interchanged between standard, wide-angle and telephoto lenses. An autofocus lens that zooms from wide angle to telephoto, such as a 28-105mm, is an excellent all-in-one lens, allowing maximum flexibility when composing reference photographs. 35mm SLR cameras accept either print or slide film in various speeds (degrees of light sensitivity).

Digital Cameras

Digital cameras (not pictured) are the newest arrival on the scene. These cameras offer a great shortcut if you have a home computer. Images are stored as digital data that can be downloaded directly into the computer. With appropriate software, the images can be manipulated in many ways before being printed out on a full-color ink-jet printer in photo-quality resolution.

SINGLE-USE CAMERA

"POINT-AND-SHOOT" CAMERA

ADVANCED PHOTO SYSTEM (APS) CAMERA

35mm SINGLE-LENS REFLEX (SLR) CAMERA

Prints

Standard and Panoramic

APS cameras offer three photographic print formats—panoramic, medium and standard—which are great aids in visualizing compositional possibilities. The panorama format is also available in single-use cameras.

35mm Slides

35mm slides aren't as easy to view as prints, but they offer superior color. A light table and photographer's loupe make it easy to view many slides at once.

Slide Viewer

When you're using a single slide for reference while painting, a battery-operated handheld viewer works well and provides a visual sensation that is almost like being at the original scene. Surprisingly, viewers that must be held to the eye like a telescope work better for this purpose than either the 2″ × 2″ (5cm × 5cm) handheld viewers or larger rear-projection viewers.

PRINTS: STANDARD AND PANORAMIC

35mm SLIDES

SLIDE VIEWER

Compiling a Photographic Sketchbook

If your time for sketching on location is limited, use a camera to create a quick sketchbook. Take photographs of interesting textures, unusual details or general scenic shots to help you capture the flavor of an area. Later, combine images from different photographs into one painting. You can improve the quality and usefulness of your photographic sketchbook by using your camera's viewfinder to "crop" the subject into a good basic composition before taking a shot. Polarizing filters and zoom wide-angle/telephoto lenses create even more possibilities for cropping and trying different angles.

Collect bits and pieces such as these flowers—they might become a painting by themselves or a detail in a larger painting.

Overall shots provide the "big picture."

Smaller details
add authenticity
and completeness.

Overall shots provide a wealth of possibilities for several smaller compositions.

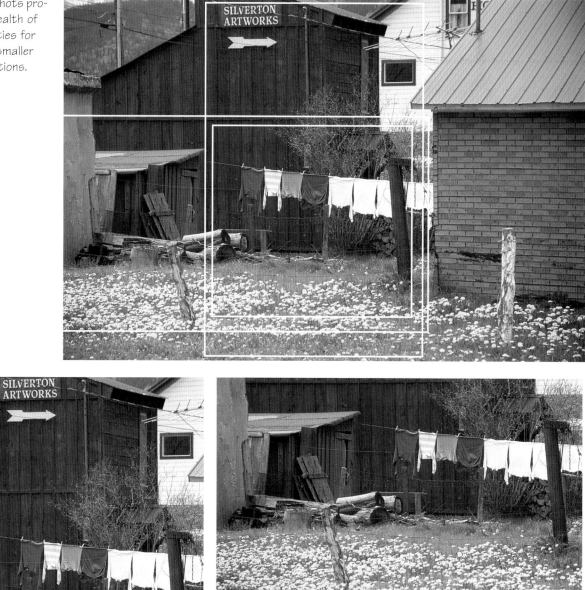

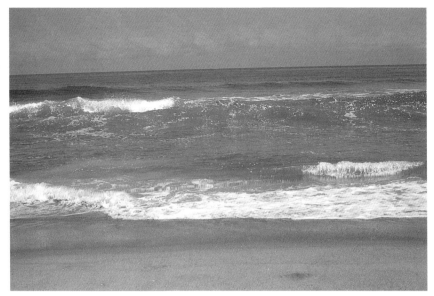

This seashore scene (first photo) lacks interest; adding shells in the foreground (second photo) or a child at play (third photo) will give it much-needed detail and a spark of life as a focal point.

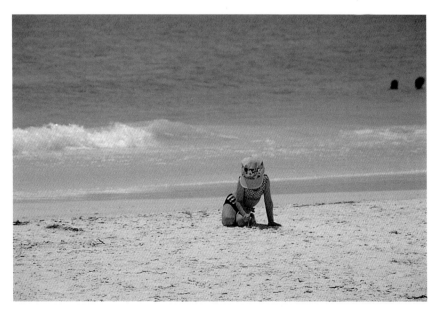

Visualize With a Viewfinder

If you have access to a reflex camera (a camera with a through-the-lens viewfinder), use the restricted field of vision to help isolate interesting subjects or to experiment with different compositions. Try horizontal versus vertical formats. Move closer or farther back. You'll soon develop an eye for spotting promising compositions.

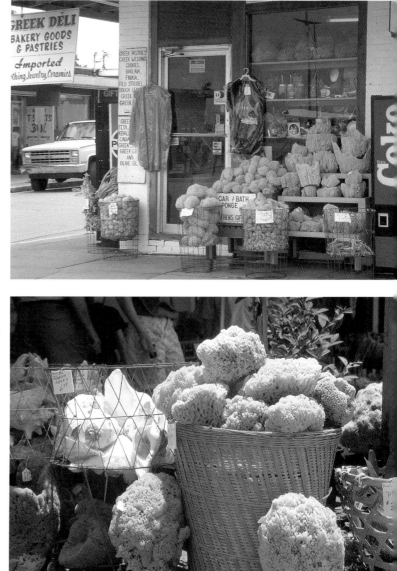

This view of a street (upper right) near the sponge docks in Tarpon Springs, Florida, is interesting. But notice how much more dramatic and focused it becomes when you move closer and frame it vertically (above), then move still closer and return to a tight horizontal composition (lower right).

Photo Sketchbook in Action

My wife, Lin, found this charming old Ford pickup sitting on someone's front lawn in Pico Rivera, California. With no time for sketching and a busy street separating her from her subject, Lin took a series of quick slides from different angles. In the studio she used her photographic sketchbook to get the details right as she sketched a view of the truck from a slightly different angle and set it in a more peaceful composition.

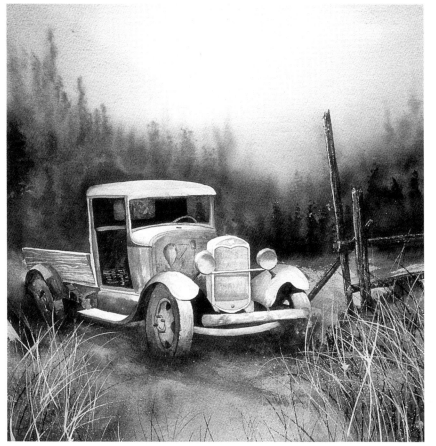

Retired
Lin Seslar
Watercolor
15″×15″ (38cm×38cm)

Zoom In on the Action

A zoom telephoto lens (for example, 70–200mm) expands compositional possibilities even further, not to mention saving a lot of walking. A telephoto lens is particularly helpful in deciding whether a subject would be better rendered close-up, as an overall scene or anywhere in between.

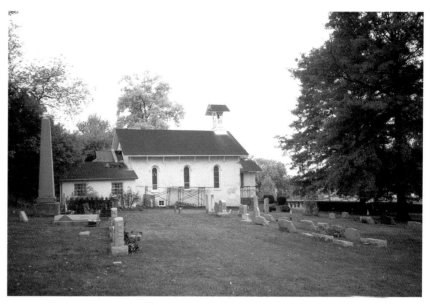

A distant view, such as this old church undergoing renovation, holds promise but is often too general to have a good focal point. With a zoom telephoto lens, it's easy to experiment with closer views.

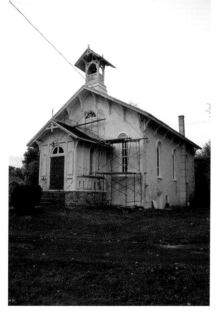

This view, taken with a zoom telephoto lens from a slightly different angle, seemed more interesting than the first overall view.

In the end, my wife, Lin, decided to zoom still closer and focus on what had attracted her to the church in the first place—the steeple's curving supports and the beautiful contrast of the steeple against the sky.

Bucks County Steeple
Lin Seslar
Watercolor
12″ × 16″ (30cm × 41cm)

Play With Perspective

Photographers often use a wide-angle lens (for example, 28mm) to compress vast panoramas into a single frame of film. This is the opposite of what artists need—for panoramas, we're better off using a panoramic camera or tapping two or more overlapping shots together to retain more natural proportion. Still, a wide-angle lens is often useful when you want to create an interesting treatment of otherwise ordinary subjects such as a barn or the looming bow of a ship.

Perk It Up With Polarization

Many colored and special effects filters are available for cameras, but for artists a simple polarizing filter is the most useful. It reduces glare, causing colors to appear richer and warmer. With a polarizing filter, your photographs will retain more of the vitality that attracted you to the scene and it will be easier to recreate that same sense of excitement in your paintings.

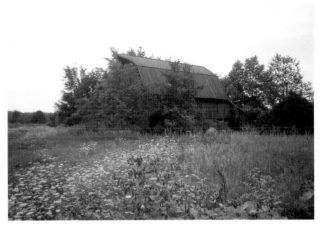

Lin was attracted to the prowlike roof extension of this old northern Indiana barn almost completely overgrown with trees. To accentuate that feature, she moved closer and shot a reference photograph with a 28mm wide-angle lens.

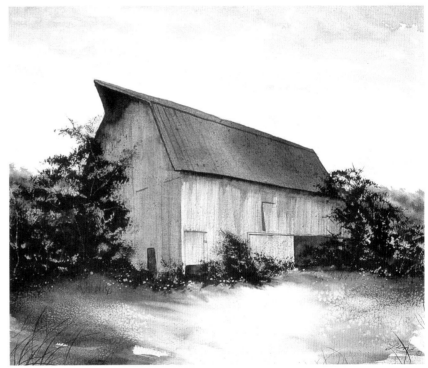

Using the wide-angle photograph as a jumping-off point, Lin eliminated most of the trees, added details to the barn, and changed the color scheme to suggest twilight rather than an overcast afternoon.

Twilight
Lin Seslar
Watercolor
13" × 16"
(33cm × 41cm)

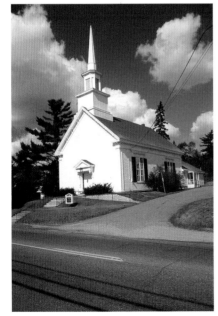

A polarizing filter helps retain the vivid colors you actually see. By reducing glare, the filter increases the intensity and warmth of colors. Skies become bluer, clouds crisper and trees greener.

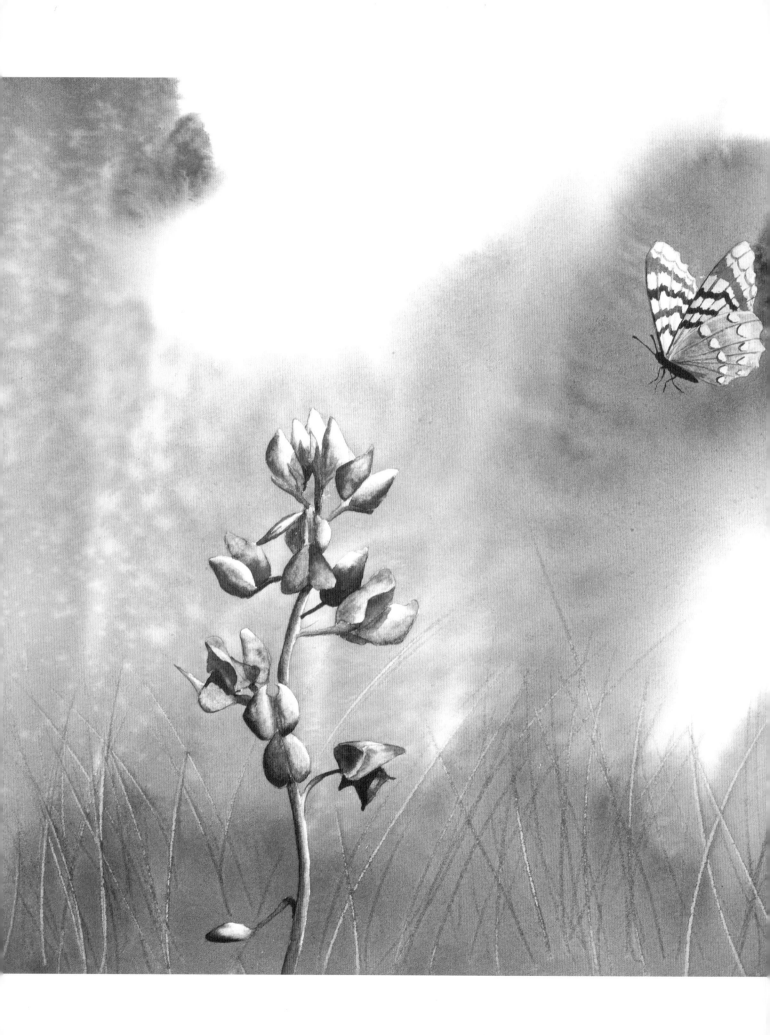

PAINTING FROM PHOTOGRAPHS—MADE EASY

Now that you have assembled your basic supplies and a stack of promising snapshots or slides, this chapter will show you how to move from rough idea to finished painting. First, you'll learn five easy ways to transform an image from your slide or snapshot into a drawing on watercolor paper. Next, you'll learn how to analyze your photographic reference for strengths and weaknesses as well as how to build the former and eliminate the latter by cropping, combining and correcting. If you have access to a computer, you'll discover another simple way to modify your reference by painting with pixels. Finally, you'll learn about applying paint. You'll learn how to choose and mix the right color, and you'll see examples of the most useful strokes and techniques for bringing out the great painting you saw hidden in your photographic reference.

Yosemite Lupine
Watercolor
12″ × 16″ (30cm × 41cm)

Enlarging and Copying Photographs

Painting from photographs simplifies the drawing process while providing wonderful opportunities for exercising artistic judgment and creativity. Some photographs can serve as the basis for a painting with little change. Others may need to be "edited" in one or more ways: Would the reference make a better statement if some elements were removed? What could be added that would make a more effective painting? Could things be arranged differently for a stronger composition? The drawing aids I'll describe in the following pages offer simple ways to modify and strengthen photographic reference.

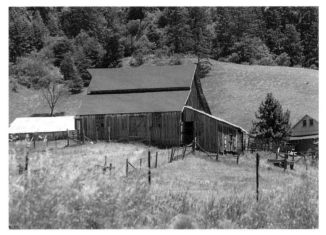

Photographs such as this provide good reference for freehand drawing and need little change to serve as the basis for a painting.

Drawing Directly From Photographs

Relying solely on your drawing skills when using photographic reference comes closest to making sketches on location. Drawing allows the greatest compositional flexibility as well as the freedom to add, remove or change anything in the image.

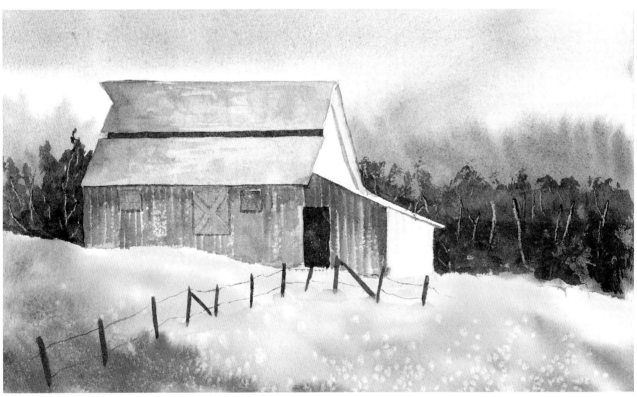

Minor editing of the composition is easy when sketching or painting directly from photographs. Here, superfluous buildings were omitted and the distant hillside was lowered so the barn roof would create a more effective contrast against the sky.

Using Grids and Pantographs

If you like working from photographic prints but drawing skills aren't your strong point, then grids and pantographs are a great aid. The grid method of enlargement is straightforward but somewhat tedious and time-consuming. As an alternative, look at art supply catalogs or Internet sites for a pantograph. This device looks like a series of short bars arranged in X shapes. Moveable pins let you change the points where the bars cross, thereby changing the amount by which an image is made larger or smaller. Although pantographs are a bit cumbersome, they're inexpensive and effective.

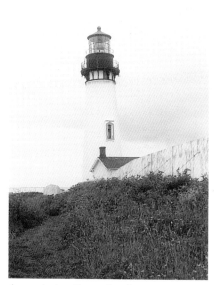

A good starting point for a painting once it is enlarged.

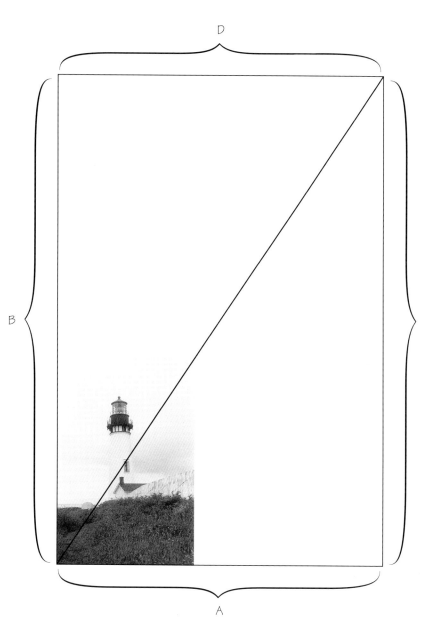

To enlarge a photograph while keeping the same proportion of width to height, draw a baseline (A) and mark how wide you'll want the enlarged image to be. Next, draw two vertical lines (B and C) to represent the sides of the enlarged image. Next, place the photograph in the lower left corner and use a ruler to mark a diagonal line upward as shown until it intersects line C. That point marks the height proportionate to the width you chose with line A. To complete the rectangle, draw a second horizontal line (D) where the diagonal line intersects the vertical line C.

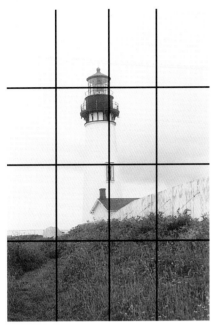

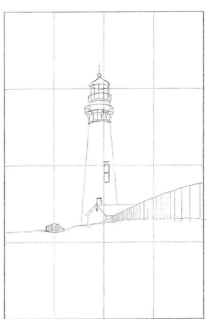

Next, on the enlarged rectangle (see previous page) repeat the grid-making sequence used on the photograph (at right). Then, using the photograph and its acetate grid as reference, draw the contents of each grid block onto the corresponding grid blocks of the enlarged rectangle.

To begin enlarging, lay a piece of clear acetate over the photograph and use a fine-point permanent marker to divide the image in half vertically and horizontally. To more easily draw the enlarged version, divide each of the newly created blocks in half once again with additional horizontal and vertical lines.

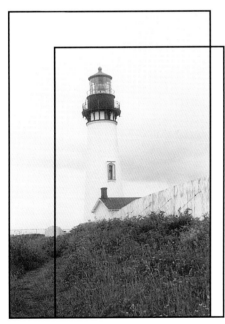

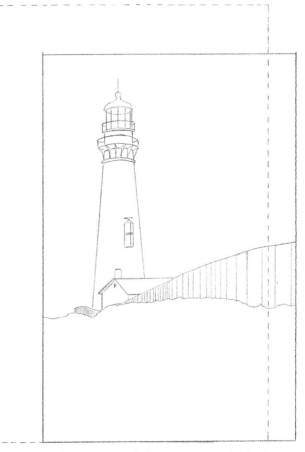

This composition would be stronger with the lighthouse placed off-center. To experiment with various placements, draw a rectangle on a second piece of clear acetate and move it around to see what placement offers the most appealing composition. When you are satisfied, tape the acetate in place.

On the enlarged drawing, mark the new rectangle showing the revised composition. In this instance, the new area to the right beyond the original drawing required that the fence be extended. On the left side, the small fence at the base of the lighthouse has been moved right about an inch from its position in the original enlargement to make a better overall composition.

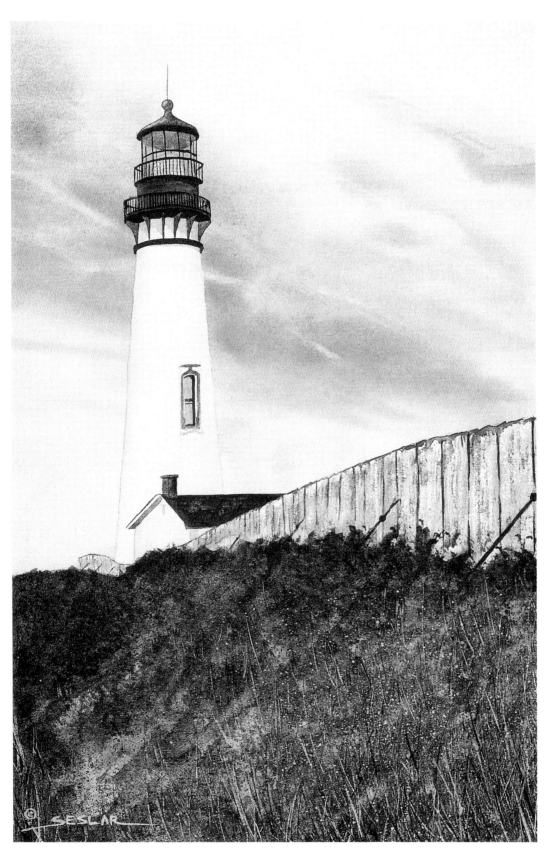

Yaquina Head Lighthouse
Watercolor
12″ × 8″ (30cm × 20cm)

Opaque Projectors

For a slightly larger investment, you can enlarge directly from photographic prints using an opaque projector. Most models project an image from the same size as the reference to ten or twelve times larger. You may need a special lens to reduce the size of the projected image.

Opaque projectors work best in a totally dark-ened room and with not more than seven or eight feet between the projector and your drawing. At larger distances, the image becomes washed out and is more difficult to see and trace. Most opaque projecters use 300-watt or larger bulbs and a cooling fan. As a result, they are hot and loud to work around, particularly in confined spaces.

If you need to project an image smaller than your reference (a bird, for example), you'll need a reducing lens.

A simpler solution is to shoot both close-ups and long shots when collecting photographic reference—that way you can select the slide that will project at the size closest to what your composition requires.

Slide Projectors

Slide projectors are perhaps the best and most versatile means of enlarging from 35mm slides. Nearly any slide projector can project a crisp image in a darkened room at distances of up to fifteen or twenty feet. With both slide and opaque projectors, it's easy to trace a portion of your subject, then move the projector to rearrange or resize other elements for a better composition. As with opaque projectors, you may need a special lens or adapter for reducing the size of the projected image.

This lovely window box with its colorful blossoms can add needed color to our window subject. To merge the two subjects, first project and draw the window, then project the window box over it. You may need to move the projector closer or farther away to match the size and scale of the window box to the window you've already drawn.

Photographs such as this offer promising reference but lack color and interest.

Here's the result!

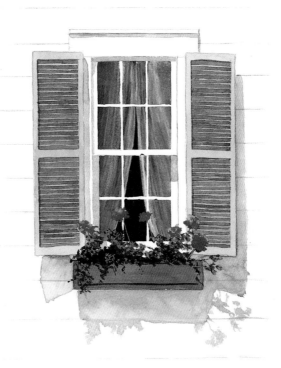

Creating Strong Compositions From Photographs

Thanks to their fixed rectangular format, most photographic prints and slides contain more content than you need or want to include in a painting. So, with photographs, good composition often means removing what is unnecessary and rearranging or adding to what is left to achieve a desired effect. Ultimately, good composition reflects an intuitive sense that something looks "right" rather than awkward or off-balance. Your intuitive sense may have a few rough edges in the beginning, but take heart—it will improve with experience. In the meantime, here are a few tips to get you pointed in the right direction.

Shapes

Shapes are the basic building blocks of good composition, so keep them interesting. Contrast large objects against smaller ones, rounded forms against geometric forms. Experiment! Draw the largest shapes from your image onto construction paper, then cut them out and test various arrangements as though creating an abstract painting. When using objects of similar shape and size, be creative—use the repeated forms to create unity and harmony. Avoid monotony by rearranging your subjects so they overlap and present different aspects of their forms.

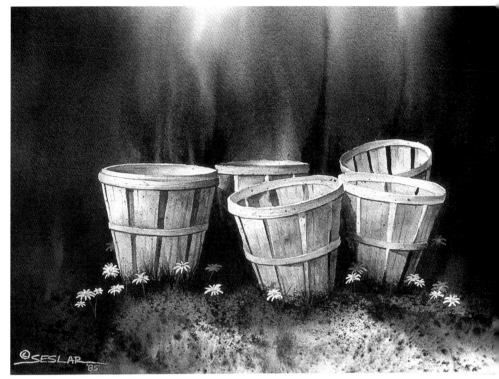

Although these baskets are nearly identical, they can be arranged into an interesting and cohesive composition by varying their orientation and positions relative to each other.

Ready for the Harvest
Watercolor
10″×14″ (25cm×36cm)

Begin with simple compositions such as this to get a better feel for the relationships between shapes and how to make the most of them.

Values

One of the most noticeable differences between a typical photograph and a painting is the range of values—lights and darks. Most photographic prints are dominated by murky midrange values. To make a painting more effective than its photographic source material, exaggerate values to create strong darks, brilliant lights and a range of midtones in between.

Most photographic reference suffers from murky value contrasts and monotonous colors.

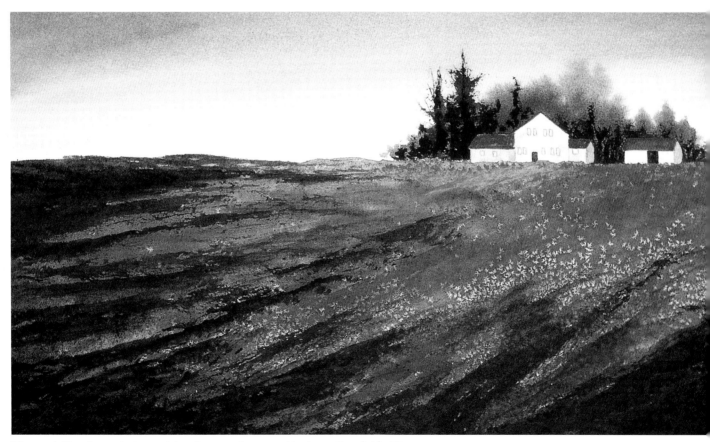

When painting from photographic reference, increase the intensity and variety of color and accentuate contrasts between light and dark values.

Roadside View
Lin Seslar
Watercolor
9" × 14" (23cm × 36cm)

Balance

Balance is one of the most intuitive facets of good composition. At its most basic, visual balance is like a playground teeter-totter. Larger elements must be positioned closer to the center while smaller (visually "lighter") elements must be positioned farther from the center. At the same time, balance implies "connectedness"—elements must be positioned close enough to each other to maintain an overall sense of unity.

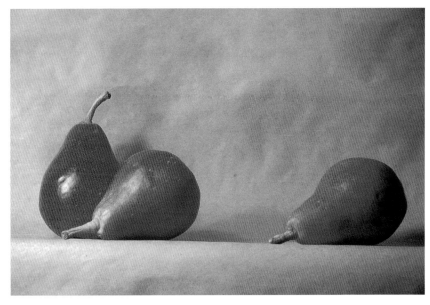

Compare this reference photograph to the following. Can you see that the elements are out of balance and do not appear "connected" to each other?

Here's a more balanced composition. Notice that the three pears "read" as a unit, even though they are separated left and right of center for visual balance.

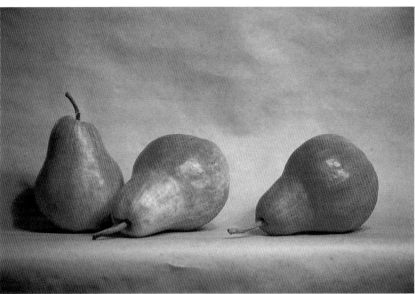

Focal Point

The focal point in a painting is often called the "center of interest." Call attention to yours by (1) moving closer to eliminate superfluous surrounding detail; (2) including a spot of brilliant color among more muted tones; (3) making certain you've created the strongest contrast between light and dark at the focal point; (4) lavishing more detail on the focal point while leaving surrounding areas less developed; (5) placing the center of interest off-center—left or right and above or below the center line of the image.

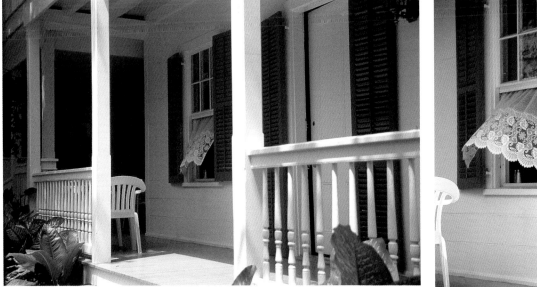

This photograph, although promising, does not have a clear focal point. The window with blowing curtain is the center of interest but vies for attention with the excessive detail surrounding it and the strong value contrast of the porch posts.

By moving closer, you eliminate extraneous detail and distracting value contrasts.

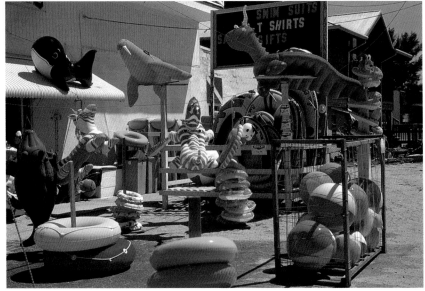

Bright colors can work for or against you. Notice how your eye darts from one brightly colored beach toy to another, unable to settle on any one as the center of attention. Although you could make a painting from reference such as this, it would require major alterations.

This photograph embodies four of the five keys to creating a strong focal point. Can you identify them? (Answer: 2, 3, 4, 5)

Cropping for Impact

As mentioned earlier, photographic reference almost always contains more visual information than you need. The solution is to crop the image to provide better balance and focus. There's nothing mysterious or difficult about cropping. Just grab a few scrap pieces of mat board and lay them over unwanted portions of the photograph to determine the most pleasing composition. Slides should be approached in the same way (though on a smaller scale). Lay the slide on a light table, then use the cardboard edges of other slides to crop unwanted portions of the image.

Scraps of matboard (white) make it simple to crop excess material from photographic prints.

To mask unwanted areas so a cropped slide can be projected, apply silver slide masking tape available from Light Impressions (at 1-800-828-6216).

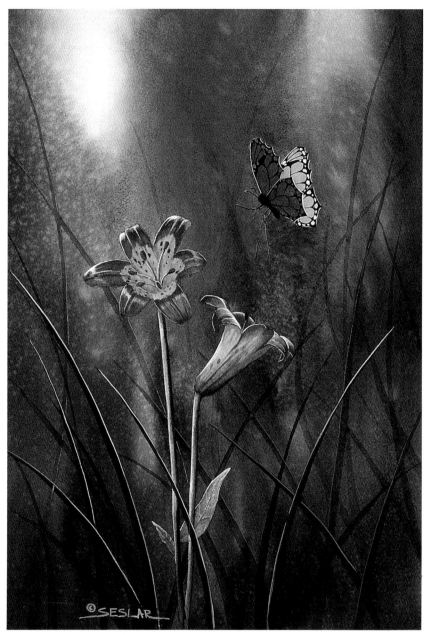

This painting, created from the cropped photo, was modified further by eliminating the blossom and stem on the left and adding a butterfly from another reference photograph.

Day Lilies
Watercolor
14" × 10" (36cm × 25cm)

Combining Several Photographs

It's easy to combine elements from different photographs. Approach it directly, as I did in the window and flower box painting (see page 35), by using a slide projector to size and position a desired element from a second slide over a drawing from a previous slide. Or, use an opaque projector to enlarge the basic image, as I did in *Day Lilies* (see page 40), then add another element, such as the butterfly, by drawing it on tracing paper to test it in various positions. Finally, if you don't own a panorama camera, you can create the same effect by taping a series of photographs together. Regardless of how you combine photographs, always keep shadows on the same side so your light source is consistent and make sure the perspectives (angles or points of view) are compatible.

If the light source in a detail you want to add is on the wrong side, simply flip the slide over and—voilà! Your light source moves to the proper side.

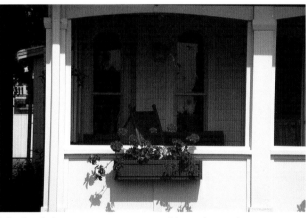

Which of these two versions would you have chosen to use with the window shown on page 35 (Answer: the flipped reference)

Transparent tape and ingenuity make it simple to create panoramic scenes.

Correcting Values and Distortions

The most common problems with photographic reference are: (1) shadow values that are too dark, and (2) distortions of perspective. Shadow values are easy to correct, provided you are aware of the problem and don't attempt to replicate the values you see exactly. Distortions of perspective usually result from using a wide-angle lens or taking a picture at an odd angle relative to your subject. These distortions can be corrected by spending a few minutes with a drafting T-square to ensure that verticals and horizontals are accurate (if subject is viewed straight-on). Use a ruler to make sure lines and planes converge toward the proper vanishing point if subject is viewed at an angle.

This photograph was taken close-up with a wide-angle lens because a wall kept me from getting back farther. As a result, the post near the center leans slightly and the one on the right looks as if it might topple at any moment. In addition, shadows throughout the image are too dark in value.

An inconvenient fence and a second-story location forced me to shoot this reference photograph at an odd angle. Still, it has enough promise to warrant a session with tracing paper and a T-square to bring things back into kilter.

Help From Your Computer

With digital imaging rapidly replacing traditional film in many applications, computers are beginning to rank high on the list of artist's equipment right alongside paints and brushes. Today you can take your film to a local store and order regular photographic prints or have your images returned on 3½" floppy disks or photo-CD. If you have stacks of prints from years past, reasonably priced flatbed and slide scanners offer another easy way to get images into a computer for further manipulation.

Several companies offer inexpensive photo-cd-iting software that makes it a snap to crop your reference in various ways. With this software, it's also easy to change colors, erase unwanted objects or add objects plucked from another scanned image. When you are satisfied with the result, an inexpensive color ink-jet printer quickly produces a print that is close to photographic quality.

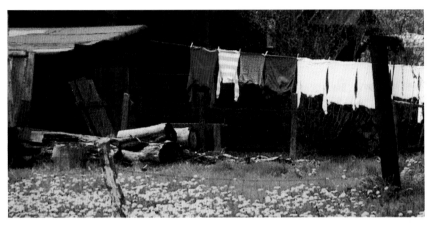

With inexpensive photo-editing software, photographs can be cropped in different ways to see which composition looks best. Compare this to the original version of this reference (see page 22). The cropped version was printed on plain paper using an Epson 720-dpi color ink-jet printer.

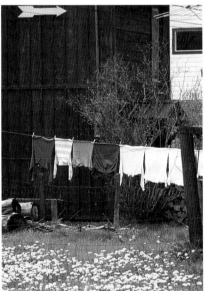

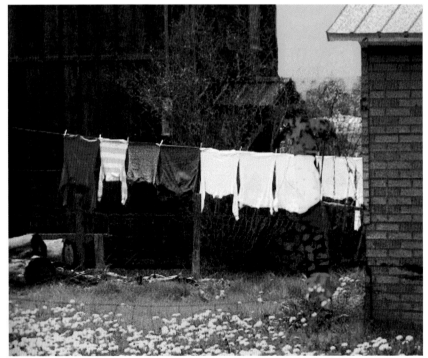

In this version of the reference, I used photo-editing software to "paint" a blue sky between the two buildings. I also painted out the dark post (originally just to the right of center, crossing the clothesline), and replaced it with a portion of the white shirt on the clothesline and portions of the cord wood, grasses and flowers below. The final result was printed on an Epson color ink-jet printer.

Basic Painting Techniques

Deciding on the "Right" Color

The "right" color is seldom the one you see in your photograph, so don't be afraid to experiment. Remember, until you intervene, the subjects you photograph represent an interesting but otherwise random assortment of objects and colors. In part what transforms them into paintings is your ability to unite the image through good composition and color harmony. Of course, in color as in music, harmony can take many forms, from soothing to seething. The choice is yours. Here are a few examples.

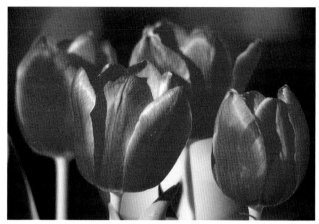

Although I liked these bright red tulips, I wanted a softer quality and more harmonious colors. I kept the blossom shapes and expanded the composition to provide more "breathing room" around them. (See the finished painting on the next page.)

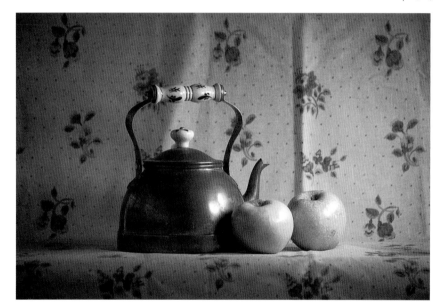

Overall, the colors in this photograph were nearly right. In fact, I could have painted from it with only minor changes. After some thought, however, I cropped the image to focus more strongly on the teapot and exchanged the apples for a couple of daisies from another photograph. (See the finished painting on page 46.)

This weathered adirondack chair had lots of character, and its color was also nearly right. Unfortunately, its surroundings weren't, so I focused on the chair and dropped the ho-hum background. (See the painting on page 47.)

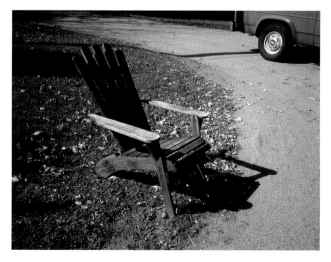

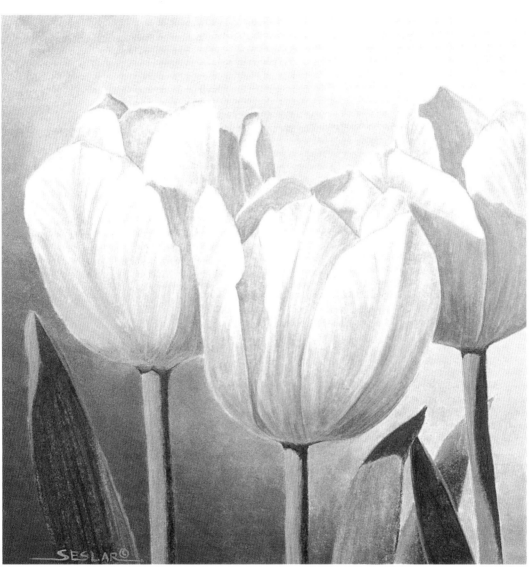

In most respects, this is a fairly literal interpretation of the photographic reference, but notice how much more painterly it becomes with small compositional changes and a more pleasing color scheme.

Tulips
Watercolor
8″ × 8″ (20cm × 20cm)

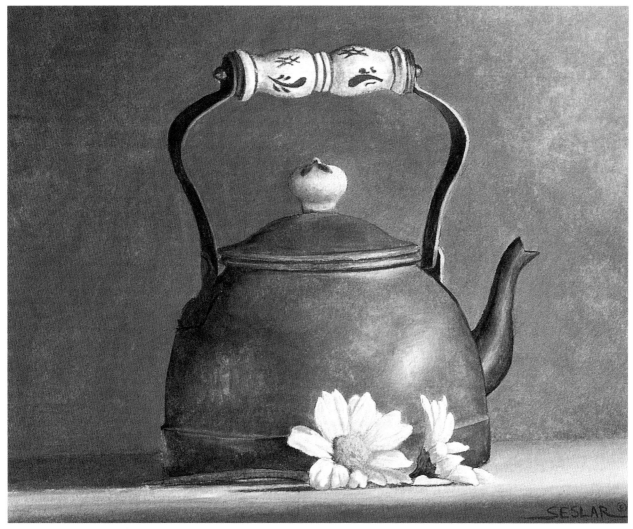

I liked the basic colors in the reference and decided to keep them, but I simplified the background still further and corrected the too-dark shadows on the teapot.

Teapot
Watercolor
8″ × 10″ (20cm × 25cm)

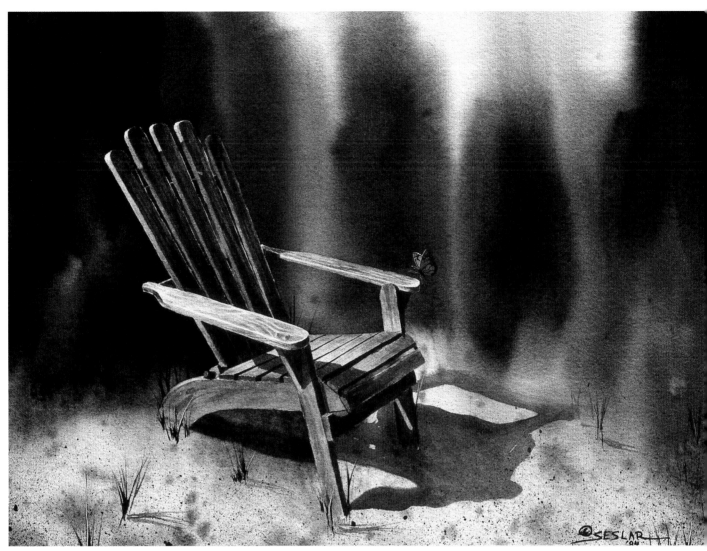

Since I had originally been drawn to the warmth and texture of the sunbaked chair, I kept it as a starting point for my composition and palette. For the new background, I contrasted muted blues against the warm wood but carefully moderated them with dark, earthy browns to unite the subject and background.

Old Friend
Watercolor
12″×16″ (30cm×41cm)

Mixing the Right Color

It's liberating to realize that the right color is a matter of interpretation. Here are a few tips to help you exercise your freedom:

• Don't assume all colors of the same name are identical. Sap Green is a warm and slightly opaque green in Grumbacher Finest colors while Winsor & Newton Sap Green is transparent and slightly cool.

• Use tube colors instead of cake colors, and squeeze out a fresh glob each time you paint. Your colors will be richer, and you won't have to watch wet-in-wet washes dry while you struggle to loosen paint from a parched cake of color.

• Get to know your colors. Stick with the same brands if possible, and remember, it's better to use a few colors well rather than use a large assortment poorly. Work with a limited palette of two or three colors until you understand the color and value possibilities they can create.

• Remember that watercolors become paler as they dry. Allow for this by making initial color mixtures somewhat darker and more intense so they'll dry to the proper color and value.

• Use similar colors to create harmony. Create contrast with value changes or complementary colors. A spot of bright color among muted tones creates an exciting focal point—for example, a red wildflower blooming among dried grasses on a forest floor.

• Keep scraps of watercolor paper nearby. When in doubt about a color mixture, paint it on a scrap and hold it over the painting where you intend to use it. Paint the same subject more than once to try different color combinations.

A photograph, no matter how attractive, is only a starting point. Mixing the right color is not about trying to match a photograph, it's about flexing your creative muscles to arrive at a harmonious color scheme that pleases you.

This variation closely echoes the photograph but is not bound by its colors.

This variation uses a different palette to change the time
of day and introduce a wider range of colors.

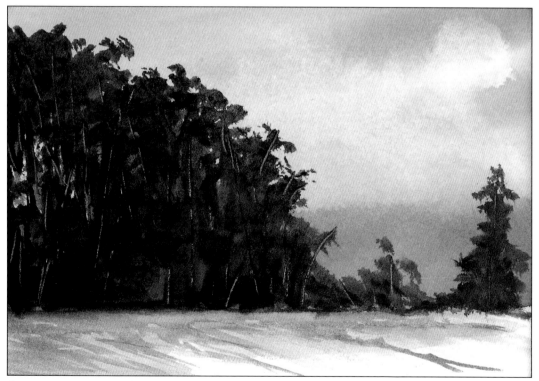

This variation uses a different palette to explore wintery grays.

Useful Strokes and Techniques

Flat Wash

To create a soft, even tone, or flat wash, wet the paper with clean water, then apply premixed color using a 1-inch (2.5cm) flat brush with steady horizontal strokes. Blot excess color puddles from around the edges of masking tape to prevent backruns. For deeper colors, premix a large quantity of the desired color, but do not prewet the paper. Test color mixtures on scraps of watercolor paper to "preview" the strength and color of the wash.

Graded Wash

Use a graded wash when you want color to change from dark to light. Premix the desired color and apply it using the techniques described for a flat wash, but add clean water with each horizontal stroke. Tilt the paper to speed or retard the movement of color. A perfectly graded wash takes practice—unless you must have an absolutely even tone, a variegated wash is usually a better option.

Variegated Wash

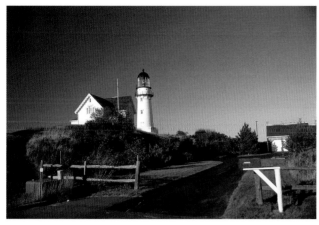

Variegated washes are useful for skies such as this and also for amorphous backgrounds (see *Pumpkin Wagon* below).

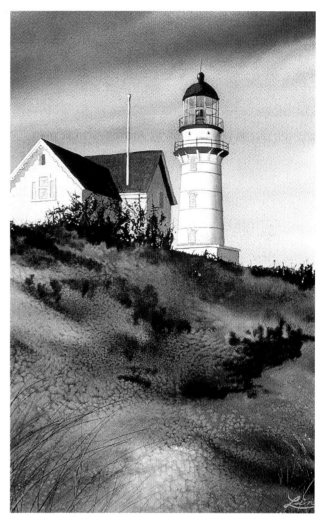

Variegated washes are the easiest washes to create. Simply prewet the paper evenly, then mix and apply the desired color or colors. For strong contrasts, use as little water as possible in the premixed color and leave areas of the paper wet but unpainted.

Cape Elizabeth Light
Lin Seslar
Watercolor
20″×16″ (51cm×41cm)

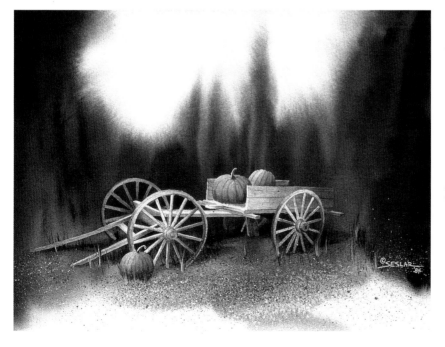

Control the flow of variegated washes by tilting the paper if necessary. Control the spread of color by varying the wetness of the paper. On really wet paper, colors bleed into each other and lose much of their intensity. On damp paper, colors feather slightly along the edges and remain close to where you placed them. Beware of backruns if the paper gets too dry.

Pumpkin Wagon
Watercolor
12″×16″ (30cm×41cm)

Drybrush

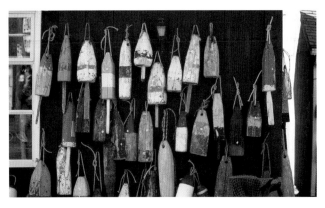

Photographs such as this provide good subjects for drybrush but should be simplified for focus and impact.

With a little more space around the subject, this photograph could be painted as is and would make an excellent subject for practicing drybrush techniques.

Drybrush strokes made by (left to right) flat, fan and no. 8 round brushes.

Flat Fan No. 8 round

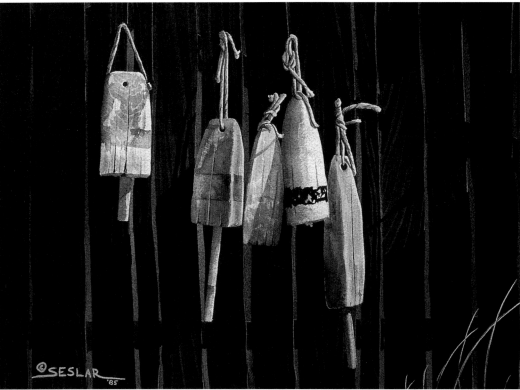

Where the Buoys Are
Watercolor
10″ × 14″
(25cm × 36cm)

My final composition makes extensive use of drybrush and is a compromise between the two reference photographs. To create a drybrush stroke, pick up the desired color with your brush, then lightly blot most of the moisture out with a paper towel. A flat, fan or round brush is ideal. Keep the brush nearly parallel with the paper and drag it lightly across the surface. Practice the stroke on scrap paper first! Too much moisture in the brush leaves a more solid trail; too little leaves barely any color. Drybrush is a tricky but useful stroke that works best on cold-pressed or rough paper.

Grasses

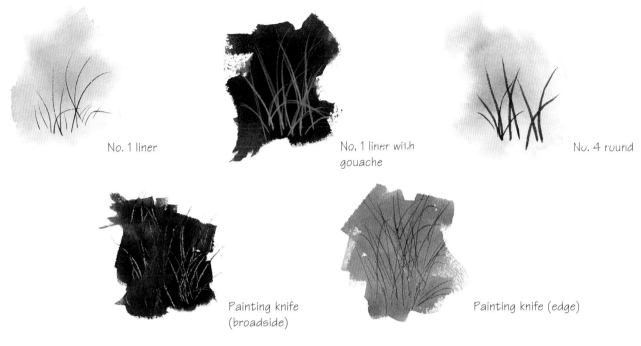

No. 1 liner

No. 1 liner with gouache

No. 4 round

Painting knife (broadside)

Painting knife (edge)

Grasses (left to right):
- No. 1 liner. Use bottom-to-top sweeping strokes.
- No. 1 liner (with gouache over darker color). Use a liner loaded with gouache white, Cadmium Yellow Pale and Sap Green to create light grasses against a darker background.
- No. 4 round. A small round leaves a fuller stroke.
- Painting knife (broadside). Dragging a painting knife through damp color leaves a lighter trail.
- Painting knife (edge). Pressing the edge of a painting knife into a wet wash leaves a crisp, fine grasslike line.

A good starting point.

Grasses add a natural feeling to many different subjects. They are easily rendered with a liner or small round brush, or with the blade or edge of a painting knife.

Spattering

Spatter texture works well to recreate the feel of sand, gravel and even plain old dirt.

Spatter texture can be created by flicking the hairs of a stiff bristle brush, toothbrush or fan brush with your thumb or forefinger. Experiment on scrap paper to see where the spatters land and how wet the color needs to be to produce the desired texture. Spatter with several different colors for added interest.

Spatters (left to right): bristle brush, toothbrush, fan brush.

Lifting Color With Paper Towels

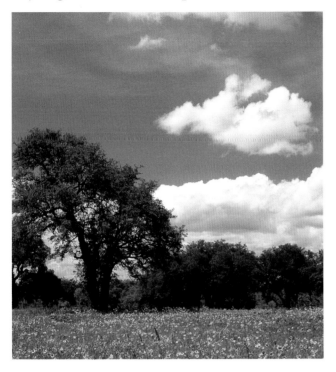

Scenes with cumulus clouds are an ideal place to lift color with paper towels.

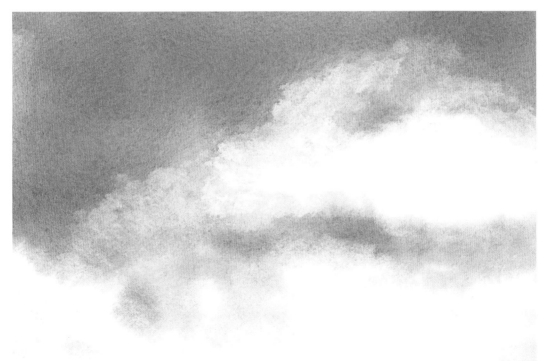

To create cumulus clouds, lay in a wash (flat, graded or variegated), then immediately press a wad of paper towels onto the paper to lift away color. In small areas, some color will remain, suggesting shadowed areas of clouds. On larger paintings, use clean water to prewet areas where you want clouds, then wash color around them to define the rough shapes. Quickly blot around the edges of the cloud shapes with paper towels to soften and feather the edges. Try this a few times on scrap paper before attempting it on your masterpiece!

Masking Fluid

If you hate painting around things, then masking fluid is for you. Rub your brush with bar soap to keep masking fluid from adhering to the hairs. Rinse and resoap your brush when little balls of rubber begin to form on the hairs.

To ensure that the paper remains white, apply a second coat of masking after allowing the first to dry. Using two coats also makes it easier to peel the dried masking after the background has been painted. Use masking tape to pick up the edge of dried masking fluid, then peel and paint!

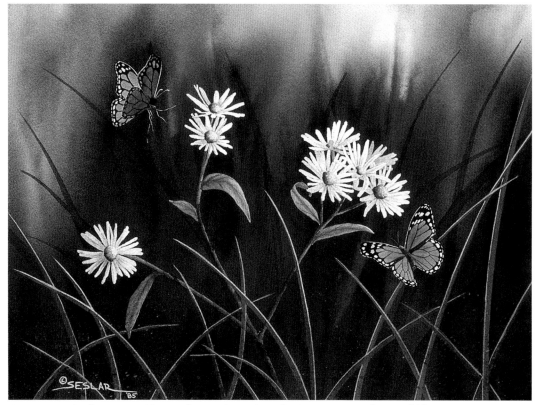

Protecting the flowers and butterflies with masking fluid makes it simple to render complex and interesting backgrounds.

Bar Harbor Wildflowers
Watercolor
12″ × 16″ (30cm × 41cm)

Salt Texture

Scenes such as this are good candidates for salt textures.

To create falling snow in the sky area using salt texture, apply a wash of color and sprinkle salt onto the paper just as the wet sheen disappears. The first textures will appear in a few minutes.

Not all colors react to salt in the same way, so use scraps of watercolor paper to see what texture results from different colors and degrees of wetness. Wetter paper will create a more subtle texture while paper not wet enough will produce little texture at all.

STEP-BY-STEP DEMONSTRATIONS

This is where it all comes together—real-life examples of a wide variety of subjects painted from photographs and snapshots. In each of the twelve demonstrations that follow, you'll see how to combine the techniques described in the first two chapters to transform photographic prints and slides into finished paintings. When you've read these over, why not find a photograph of your own that's similar and try applying the same steps? As you paint, remember: Don't judge your efforts by how closely they match the photograph you started from. How you paint is and should be an expression of your innermost personality. If your first attempts aren't everything you'd hoped for, be gentle when critiquing your work and keep in mind that even a skyscraper is built one brick (OK, one steel beam) at a time. Rest assured, you will get better with each new painting.

Wildflowers
Watercolor
12" × 16" (30cm × 41cm)

Demonstration 1: Daisies

Daisies make a wonderful subject because they can be found nearly anywhere and grow in a variety of colors. They also have well-defined shapes that make them ideal candidates for any one of the enlarging methods discussed earlier. The four photographs shown here are from my photo sketchbook. Any one of them could be made into a lovely painting by applying the techniques described in the first two chapters of this book. I chose the fourth for this demonstration because I wanted a photograph that could be painted with a minimum of editing and alteration.

This photograph has real potential. It needs to be cropped to focus on the daisies, and more daisies need to be added. It could also benefit from more color—perhaps something other than white daisies or a mixture of colors.

This photograph could make an interesting painting, but it definitely needs more and brighter color. The shadow area on the right should be cropped and lightened, or eliminated completely, to improve focus on the center of interest. Finally, bright yellow daisies and a spattered terra-cotta texture on the foreground sidewalk would really bring this scene to life.

This is the least promising photograph. Still, it could be used by cropping to focus on the central group of five daisies. Daisies could be traced from other photographs and placed in this scene to make the cropped image more lush. Once cropped, this image could benefit from more and stronger colors in the foliage and flowers themselves. Regardless of its merit as a subject on its own, photographs like this are worth keeping as a "boneyard" for scavenging additional blossoms for other compositions.

Lin chose this photograph for the demonstration because it needed just a little cropping and had a fairly sound composition that could be painted in many different ways. The unaltered photograph has a height-to-width ratio of 2:3. Lin could have retained this ratio after cropping, but, just for fun, she decided to try a square composition.

Cropping tightened the focus and edited out one unwanted element—the isolated daisy in the lower left corner. Lin also decided to omit the unopened bud and blurred blossom just to the left and behind the main group of blossoms.

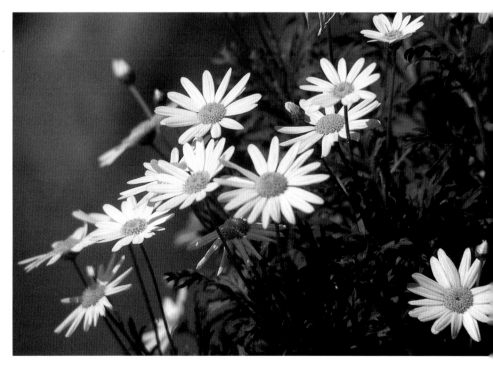

Step 1: Drawing and Masking

After using strips of matboard to crop in from the sides, Lin settled on a square composition. She then enlarged the image onto an 11″×11″ (28cm×28cm) piece of Arches 300-lb. (638gsm) hot-pressed watercolor paper using a slide projector and a 5H pencil.

Tape all four sides of the watercolor paper to a drawing board with 1″ (2.5cm) masking tape. Mask out the whites of the blossoms using gray masking fluid and a no. 4 round brush. Before dipping the brush into the masking fluid, scrub the bristles on a bar of Ivory soap to keep the masking fluid from sticking to them. When small balls of dried masking form on the bristles, wash it out and renew the soap before proceeding.

Leave the shadowed blossom (lower center) unmasked (except for highlights) at this point. When all blossoms have been masked, allow them to dry. Then apply a second coat of masking fluid to make sure the white of the paper is fully masked and to make it easier to remove the dried film later on.

Step 2: First Wash

Once the masking is dry (a small hair dryer can help), wet the entire paper surface with clean water. As it soaks in, mix a dark wash of Cerulean Blue and Cobalt Violet and apply with a 1-inch (2.5cm) flat brush. Working from top to bottom, begin adding Burnt Sienna to the basic mixture as you cross into the lower half of the painting. If the first wash seems too pale, darken the color and repeat the top-to-bottom sequence before the first wash has dried.

Step 3: First Layer of Dark Green Foliage

When this wash is dry (don't forget your hair dryer), soap up a no. 4 round brush and apply gray masking fluid over the petals of the blossom that you left unmasked earlier. Then, with a dark mix of Hooker's Green, Cobalt Violet and Sepia, paint the stems and several distinct leaves identified in your pencil drawing. Next, mix a good quantity of Hooker's Green, Cobalt Violet, Sepia and Alizarin Crimson for the darks of the foliage. Using a no. 8 round brush, apply the dark mixture to the foliage.

Step 4: Apply Light Green Accents to Foliage

Using a fan brush, scrub a semi-opaque mix of Permanent White gouache, Cadmium Yellow Light and Winsor Green over the dark green foliage color to establish highlights.

Step 5: Apply Red and Blue-Purple Accents Within Foliage

Again using the fan brush, add color accents throughout the foliage with a semiopaque mix of Permanent White gouache and Cobalt Violet. To provide contrast, add Alizarin Crimson to the mix. Finally, restate the flower stems and some grass using a dark mixture of Hooker's Green, Cobalt Violet, Sepia and Alizarin Crimson. Highlight the stems and leaf edges with the light green mixture used in step 4 (Permanent White gouache, Cadmium Yellow Light and Winsor Green).

When the painting is dry (hold the back of your hand to the paper surface—if it feels cool, allow more drying time), use masking tape to carefully lift one edge of the masking film and peel it off to reveal the white paper beneath.

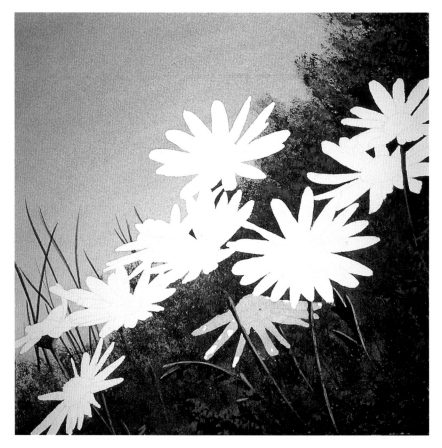

Step 6: Flower Centers and Petals

Paint the blossom centers with a basic wash of New Gamboge, then darken the lower edges with varied mixtures of New Gamboge and Burnt Sienna. To complete the painting, render the petal details (shadows and creases) using a no. 4 round brush and a dilute mix of Cobalt Blue and Burnt Umber.

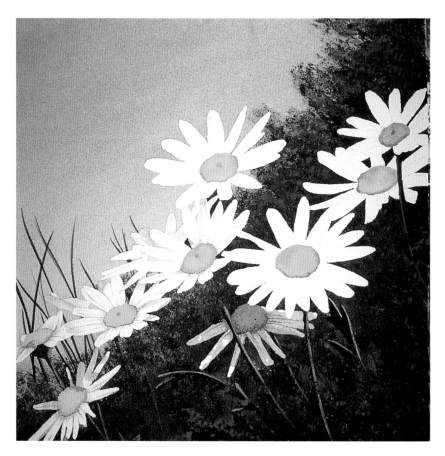

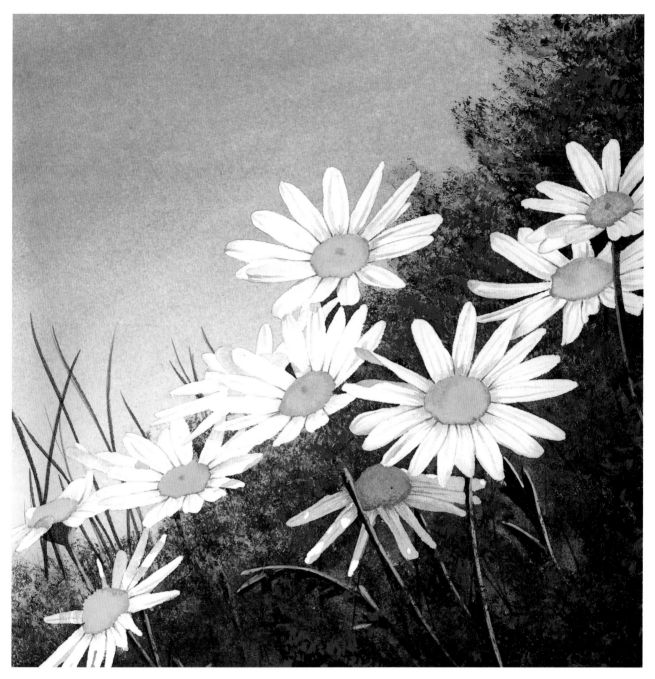

Daisies
Lin Seslar
Watercolor
11″×11″ (28cm×28cm)

Demonstration 2: Thistle and Butterfly

Thistles and butterflies can be found nearly anywhere. They're so common we sometimes forget what interesting subjects they make. For this demonstration, I've assembled an assortment of thistle and butterfly references from my photo sketchbook. Even so, I found it necessary to verify certain structural details by referring to a field guide.

A number of field guides are published to assist in identifying many species of plants and animals. I used *The Audubon Society Field Guide to North American Butterflies* (Pyle, 1981) and *A Field Guide to Pacific States Wildflowers* (Niehaus & Ripper, 1976). The former I used to check the number of legs on the Monarch butterfly and the general placement of the white spots on its wings. The latter I used to get a feel for the general appearance of the blossoms and leaves of the thistles. The wildflower field guide contained line drawings rather than photographs, which made it easier to distinguish the leaf shapes.

However, unless you are actually doing illustrations for a field guide, strict accuracy should take second place to artistic license. Even if you can identify every minute detail, using that level of information is seldom necessary to create a successful painting. Onward!

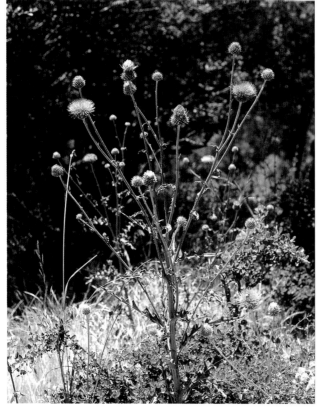

This photograph is an excellent general reference of thistles in a natural environment. Although it lacks focus because the blossoms are spread so far apart, it shows leaves and thistle blossoms in a variety of forms, from unopened buds to withering blooms. Seeing how the thistle blossoms and stalks (center left) contrast against the dark background, I decided to strive for similar contrasts in my finished painting.

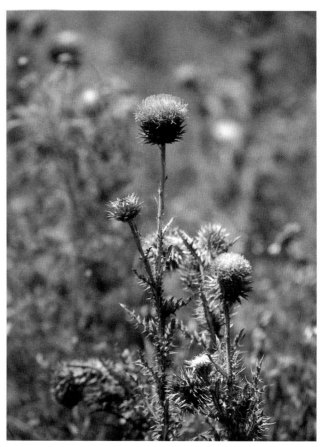

I selected this photograph for the painting. It's a fairly close-up view, so blossom and leaf details can be made out, but it lacks the dramatic contrasts I found appealing in the first photo. Fortunately, a darker background is well within my artistic license. For more color contrast and interest, I decided to add a butterfly.

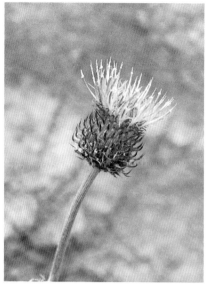

To paint thistle blossoms reasonably accurately, close-ups like these are needed. Between them they provide a wealth of information about thistles, showing a barely opened bud, a young blossom and one fully "deployed." The texture and color of the blossoms and the nettlelike spikes at their base are clearly visible. Subtle details are also worth noting: (1) the distribution of light and shadow over the blossoms; (2) the stems are relatively smooth; (3) on the mature blossom, the green spiked base looks like a slightly flattened egg stood on end; (4) the spiked base appears to have volume and form because the light area near its center fades into shadow below the bloom as well as at its base and sides.

I considered using this yellow swallowtail but decided the orange of a Monarch butterfly would be more dramatic against the purple thistle blossoms. I'll save this one for another day!

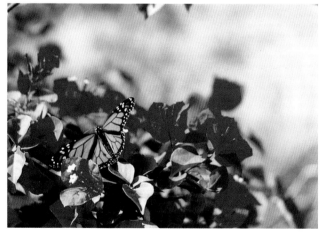

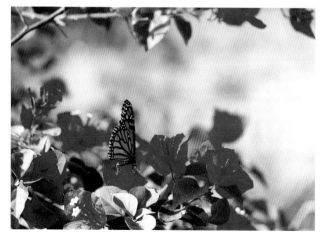

Returning to my archives, I retrieved these photographs of a Monarch flitting among bougainvillea blossoms. Neither pose is exactly right for this composition, but they are a great resource for this butterfly's shape and color, and I'll refer to them as I draw a somewhat different pose on a sheet of tracing paper.

Step 1: Sketching Basic Components

Using an opaque projector, I traced the basic outline of three blossoms, stems and leaves on a sheet of tracing paper. Moving the projector closer, I cropped the image and shifted it slightly to the left to make room for the butterfly. I traced various details, reminding myself this wasn't scientific illustration—I did not need every tiny detail. What I needed was more like caricature, a few key features to make this subject readily identifiable.

Using my photos for reference, I sketched a Monarch in flight on tracing paper. Then I discovered I'd drawn the butterfly too small relative to the thistles and I had it flying in the wrong direction! To correct this, I drew a grid over the sketch and a second, slightly larger, blank grid, then transferred the sketch grid box by grid box to create a larger butterfly sketch. Of course, if you have access to a copy machine that enlarges or reduces, you can accomplish the same result in far less time! Finally, I flipped the tracing over to get the butterfly flying in the right direction (that's why the numbers appear backwards).

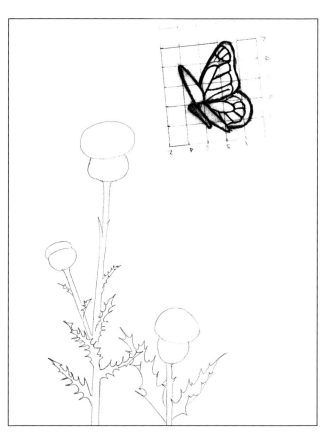

Step 2: Transferring Sketches to Watercolor Paper

With everything sketched and in proportion, prepare to transfer your drawing by using a no. 2 office pencil to retrace the drawings on the back of the tracing paper. Now align the tracing paper faceup over a 12″×8″ (30cm×20cm) piece of Arches 300-lb. (638gsm) cold-pressed watercolor paper and, with a 5H pencil, redraw the lines on the front of the tracing paper. This will transfer the no. 2 pencil onto the watercolor paper. Lift the tracing paper as you work to verify that the complete drawing has transferred. Reinforce any faint areas with the 5H pencil.

Step 3: First Washes

Then apply one coat of liquid masking to stems, leaves and blossoms, and allow it to dry. Then apply a second coat to ensure that the whites are preserved and the masking film will be thick enough to peel easily later.

Wet the entire surface of your paper with clean water, making sure there are no dry spots. As the water soaks in, mix a dark wash of Sap Green, Burnt Umber and Charcoal Gray. Apply it with a 1-inch (2.5cm) flat brush, starting at the base of the image. Using upward strokes, draw the color up into the wet paper and along the left side, adding just a hint of New Gamboge near the top. Keep the upper right corner unpainted to suggest that the light is coming from right to left.

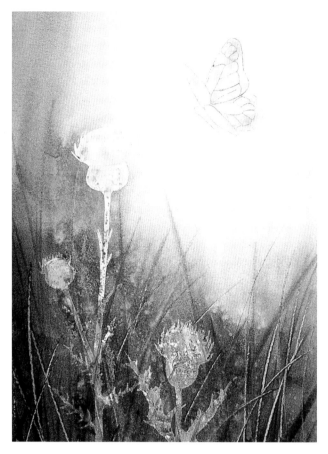

Step 4: Indicate Grasses and Remove Masking

If your first wash dries too light (like mine!), make sure the paper is completely dry, carefully rewet the surface with clean water and repeat the same wash colors as before with a slightly darker mix. As the sheen begins to fade from the paper, grab a no. 8 round brush and load it with the same dark mixture. Using upward strokes, quickly indicate a number of blurred shadowy grasses to reinforce the illusion of depth. Let dry, and peel the layer of dried masking off to reveal the white of the paper beneath the blossoms, stems and leaves.

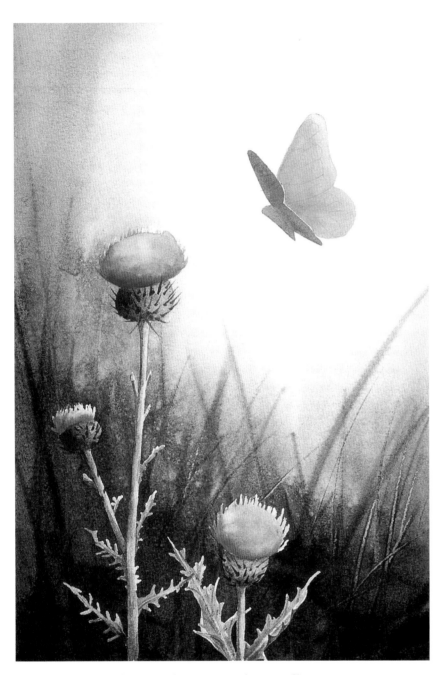

Step 5: First Washes on Blossoms and Butterfly

Using the basic color mixture from the background, add more water and a touch of New Gamboge and begin laying in color on the stems, the leaves and the bases of the blossoms. Use a no. 4 round brush, and keep the paint fairly fluid, adding water to the mixture as necessary. With the same brush and less water, darken the bases of the blossoms and indicate the spikes with short lifting strokes.

Next, wash in the rough colors of the blossoms using Alizarin Crimson, Grumbacher's Thio Violet and Chinese White. Vary the mixture to make certain the blossoms are darker at the base and along the left side to suggest the light source and to give the illusion of volume.

Wash in the sunlit area of the butterfly's wing with a mix of New Gamboge and Cadmium Orange. For the smaller wings in shadow, add Burnt Sienna to the mixture.

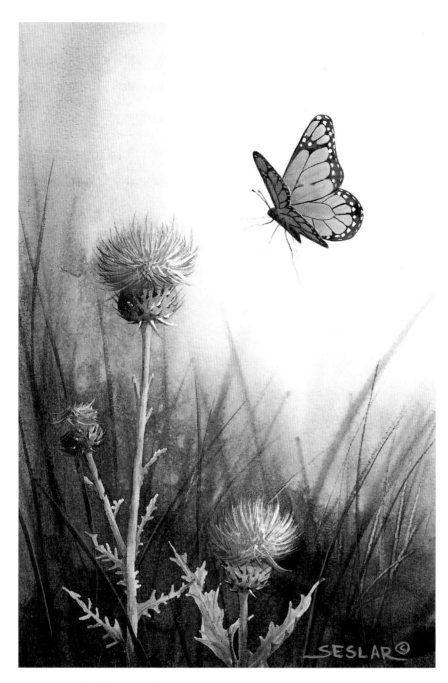

Thistles
Watercolor
12″×8″ (30cm×20cm)

Step 6: Finishing Touches

With a no. 1 liner, highlight the barbs at the base of each blossom with a mixture of New Gamboge and Chinese White. Next, with the same brush and various mixtures of Alizarin Crimson, Grumbacher's Thio Violet and Permanent White gouache, indicate the pink and purple fibers of the thistle's blossoms, taking care to maintain the light source and sense of volume.

For the butterfly, use Charcoal Gray and a no. 4 round brush to establish the black fringes and lines within the wings. When this is dry, add the white spots on the sunlit wing using Permanent White gouache; for the spots on the shadowed wing, add Charcoal Gray. Before rendering the antennae and legs with a no. 1 liner and Charcoal Gray, refer to a field guide to check the placement of the Monarch's legs.

To complete the painting, use a no. 8 round brush and basic dark green mix from the background washes to establish a few more definite grasses in the foreground. When the grasses dry, accent them with a mixture of New Gamboge, Hooker's Green and Chinese White.

Demonstration 3: Potted Geraniums

Potted flowers offer a refreshing blend of man-made and natural subjects and textures. If you keep your camera handy, you'll come across compositions of this type that practically beg to be painted just as they are. You can improve your reference photographs by finding a camera position that contrasts the bright colors of flower blossoms against a darker background (shadows, trees, etc.). Remember to move in close so your subject has a strong center of interest.

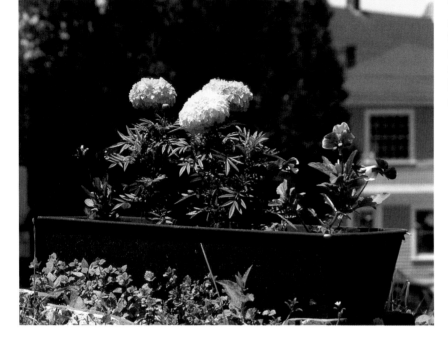

The contrast of yellow blossoms against dark, distant trees is positively captivating. Overall, the image would be stronger if the distant house were replaced with sky and if the flower box were a different color—terra-cotta, perhaps?

This photograph has wonderful color and texture, but the shape of the coal bucket poses some compositional balance problems. The strong angle of the bucket's left side could be broken up by adding smaller potted posies from another photograph. Beyond that, the light area in the lower left could be darkened to allow a gradual transition into shadow. What would you do?

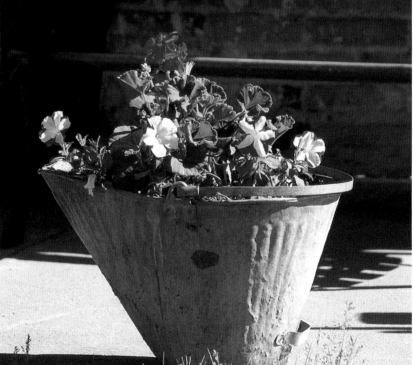

When I came across this photograph, I thought I'd paint it exactly as I saw it. I liked the basic arrangement of elements and strong light-to-dark contrast between foreground and background. Then, looking at the scene with an objective painter's eye, I realized the background was too busy and the white geraniums weren't colorful enough. I also felt that a butterfly would add a nice touch of life and the suggestion of motion.

A quick search of my photo archives turned up two reference shots of red geraniums. Monarch butterflies are a favorite of mine, so I decided to use one in this image. Having no reference photos in the exact position needed, I sketched the shape on tracing paper using my trusty field guide to butterflies and references like those in the thistle demonstration.

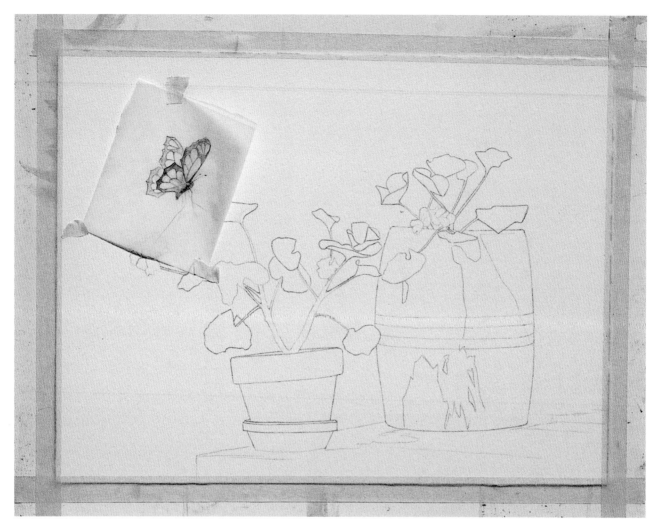

Step 1: Drawing

Because there was a lot of detail, I selected a
12″×16″ (30cm×41cm) piece of Arches 300-lb.
(638gsm)cold-pressed watercolor paper and used a
slide projector to project my reference. Using a 5H
pencil, I drew the major forms and shadows. I drew
the butterfly on a separate piece of tracing paper
so I could move it around to find the best composi-
tional balance.

Step 2: Masking

Apply gray masking fluid over the pots, stems, blossoms and butterfly. When the first coat is dry, apply a second coat to make sure no color bleeds through and to create a thicker film that is easier to remove later. Once the major elements have been masked, analyze the abstract arrangement of forms as a final check before you begin painting. Tape all edges down with masking tape.

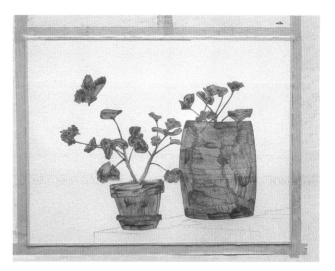

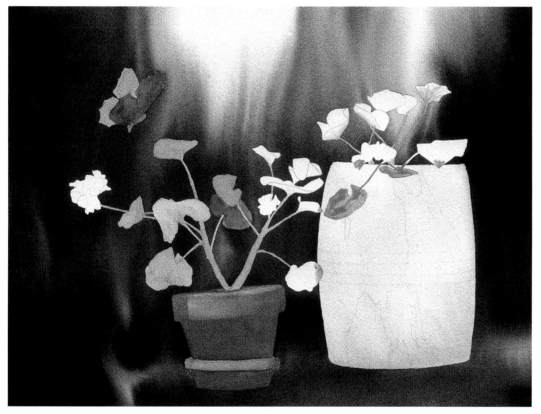

Step 3: Background and Preliminary Washes

Wet the entire background with clean water. With a 1-inch (2.5cm) flat, apply dark washes using mixtures of Phthalo Green, Charcoal Gray and Cadmium Yellow Pale. Apply color at the bottom and sweep upward, leaving two areas near the center free of paint. As the wash begins to dry, wipe excess paint and water from the tape edges with paper towels. Turn the drawing board upside down to help the wash bleed to the top of the image.

When the wash is thoroughly dry, lift an edge of the dried masking with masking tape and peel it to expose the reserved white beneath. To paint the shadows of the larger pot without painting around the leaves overlapping it, remask the leaves before proceeding.

With a no. 4 round, lay in a few preliminary washes on the butterfly (New Gamboge, Cadmium Orange, Burnt Sienna) and on the leaves and stems (Sap Green, Yellow Ochre). Render the clay pot with a ½-inch (1.25cm) flat, using various mixtures of Burnt Umber, Burnt Sienna, Cadmium Red, Yellow Ochre and Charcoal Gray.

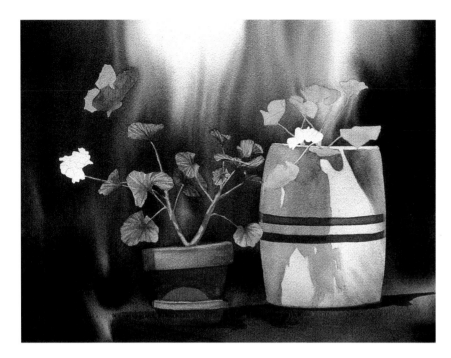

Step 4: Shadow and Leaves

With the overlapping leaves masked, warm the larger pot with a pale wash of Cerulean Blue and Yellow Ochre. After it dries, paint the cast shadows on the pot using mixtures of Ultramarine Blue and Burnt Sienna. Then, paint the two bands in the center with a darker and somewhat bluer mixture of the same colors.

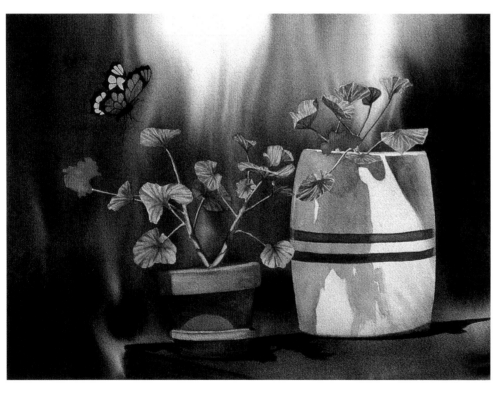

Step 5: Leaf Detail and Blossoms

Paint the remaining leaves with washes of Yellow Ochre, Sap Green and Charcoal Gray. With a no. 4 round, drybrush shadows and creases on the leaves with the same color mixtures. Next, paint dark edges and inner lines on the butterfly's wings using a no. 4 round and Charcoal Gray. After that, wash the geranium blossoms with Cadmium Red, and then warm the result with a wash of New Gamboge.

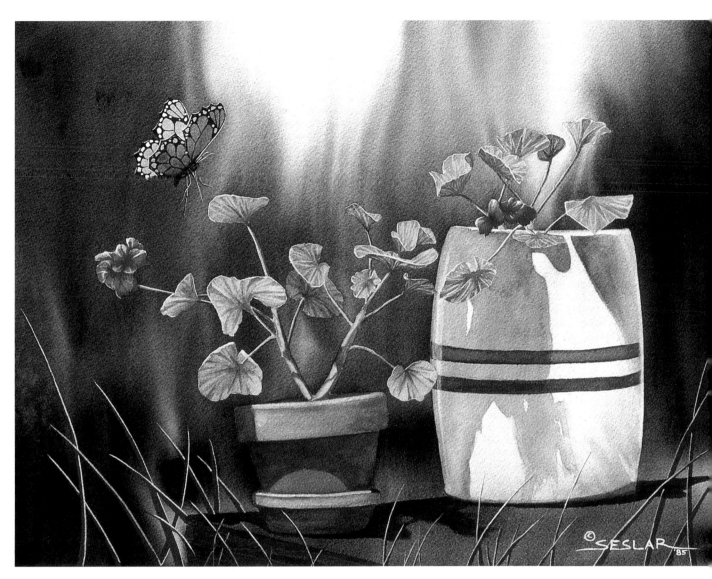

Step 6: Complete the Painting

Add dark foreground grasses with a mixture of Periwinkle Blue, Alizarin Crimson and Lemon Yellow (all gouache colors). Selectively highlight the edges of leaves, stems and grasses with a mix of Permanent White, Lemon Yellow and Permanent Green Light (all gouache colors). Lastly, use Permanent White gouache to indicate the white spots on the Monarch's sunlit wing; for the shadowed wing, mix a gray from Charcoal Gray and Permanent White gouache.

Potted Geraniums
Watercolor
12″ × 16″ (30cm × 41cm)

Demonstration 4: Pears on a Shelf

Fresh fruits and vegetables offer an amazing variety of subjects. You'll be surprised at how many different colors, shapes and sizes are available.

To move from still-life subject to festive fruit salad more quickly, you'll find it easiest to create and photograph a series of arrangements you can come back to later. I usually shoot a couple of rolls (seventy-two shots) at one time—if I get three or four strong shots per roll, I've done well.

I arrange setups on a small wooden table and place a piece of gray matboard a few inches behind the fruit. A photoflood with a 500-watt bulb lights the setup from right to left, slightly in front of and above the table to create strong shadows and highlights.

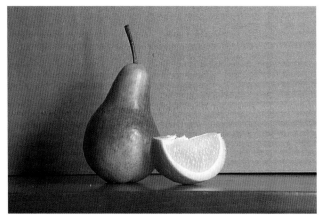

Pick up other types of fruit for additional color and shape options. Experiment with different combinations and arrangements. In this photograph the colors and shapes are interesting together—almost.

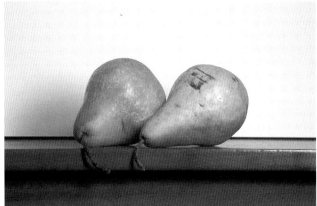

I would definitely consider this arrangement as the basis for a painting. It would be better if only one stem crossed the front shelf edge and the pears were at different angles to each other. I'd also crop to focus better on the subject.

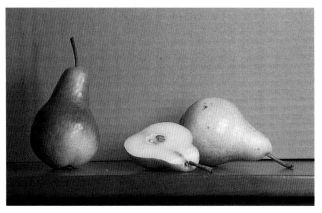

This arrangement has promise but isn't one I'm likely to paint. No matter—it's all part of learning what makes a pleasing composition.

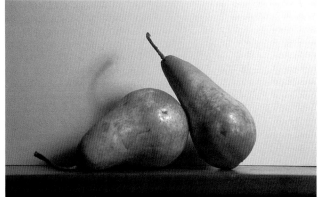

I like this composition: the shapes, colors and the cast shadow behind the left-hand pear. The stems have nice lines, and the dark area below the shelf contrasts nicely against the lighter area above.

Step 1: Masking

On a 7½″ × 10″ (19cm × 25cm) piece of Arches 300-lb. (638gsm) cold-pressed paper, transfer or sketch your subject (I used a slide projector to enlarge and position the image). Draw the pear outlines with a 5H pencil but mark the positions of the shelf edges (rear, front, bottom) with a light ¼″ (.6cm) line. With a T-square, make sure the lower paper edge is horizontal, then tape the paper in place. Align the T-square with the shelf edge marks and draw them with a 5H pencil.

Two strips of ¾″ (1.9cm) masking tape mask the rear and lower edges of the shelf. Apply one coat of gray masking fluid to the pears (but not the stems).

When dry, apply a second coat to ensure complete coverage.

Step 2: Background Wash and Below the Shelf

Wet the upper area with clean water. As it soaks in, mix a dilute wash of Yellow Ochre and Grumbacher's Thio Violet. Test on a scrap of watercolor paper; if too cool, add more Yellow Ochre. With a 1-inch (2.5cm) flat brush, apply the mix as a graded or variegated wash—darker at the bottom left, lightest in the upper right corner (light source). As the sheen begins to disappear from the paper, use a no. 8 round to paint the cast shadows above and left of the left-hand pear with a dilute mix of Burnt Umber and Charcoal Gray.

Wet the area below the shelf. Mix a dark wash of Burnt Sienna, Ultramarine Blue and Charcoal Gray, and apply with a 1-inch (2.5cm) flat brush; if the wash is too light when dry, reapply it without prewetting the paper.

After both washes are thoroughly dry, remove the masking tape and masking fluid from the shelf and pears.

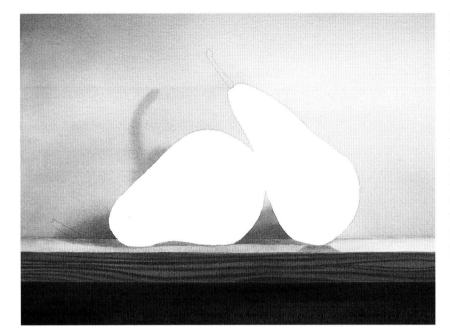

Step 3: Shelf Detail

Using a no. 4 round, begin painting the upper surface of the shelf with dilute mixtures of Yellow Ochre and Burnt Sienna. For the shadows, add Burnt Umber. Switch to a ½-inch (1.25cm) flat brush, and apply a darker mixture of Burnt Sienna to the front face of the shelf. When that is dry, use a no. 4 round to apply wood-grain texture using dark mixtures of Burnt Sienna, Burnt Umber and Charcoal Gray.

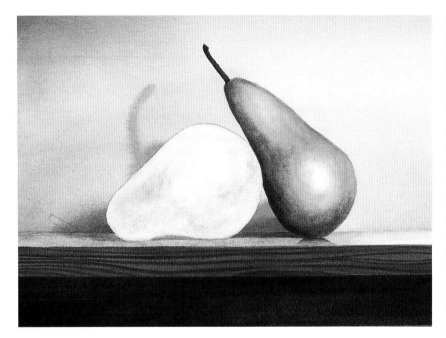

Step 4: Pear Work

Begin washing in the right-hand pear using a no. 8 round and dilute washes of Yellow Ochre. Prewet the highlight with clean water, and paint the wash around it to begin developing a sense of volume. While the initial wash is still wet, continue working with the no. 8 round, this time adding dilute Burnt Sienna around the inner edges of the pear and across the center. Still working wet, apply Burnt Umber to the same areas, grading from dark to light toward the highlight area. Restate the darkest shadow areas (left side) using mixtures of Burnt Umber and Charcoal Gray. To complete the first pear, render the stem using very dark mixtures of Burnt Umber and Charcoal Gray.

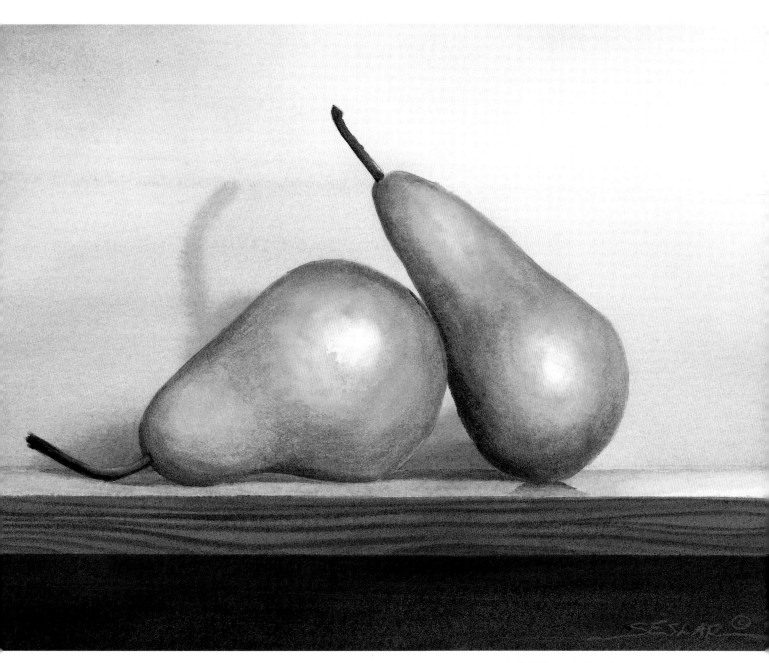

Step 5: Finishing Touches
Paint the left-hand pear in the same manner and with the same colors as the right-hand pear. Darken the shadows below the pears to bring all the values into synch. Add highlights to the stems using mixtures of Alizarin Crimson, Cadmium Yellow Pale and Permanent White gouache.

One final tip: You can see that the reference photograph and the finished painting clearly depict the same subject, but they are not identical. Among other things, the colors are different and the wood grain on the shelf edge is more pronounced. These are just a couple of the options available to you under your "artistic license"—always keep in mind that, although photographs are a tremendous help, you needn't be a slave to them or doubt your talent because you can't replicate them exactly.

Still Life With Two Pears
Watercolor
7½" × 10" (19cm × 25cm)

Demonstration 5: Apple and Grapes on Linen

I enjoy painting apples because they're available year-round and present interesting compositional challenges. An apple is basically a modified sphere—no matter how you orient it, the shape fits neatly inside a circle. Of course, that makes it more difficult to create a satisfactory composition using two apples because the shapes are too similar, so I usually pair an apple with a different fruit, such as grapes. Apples can also be placed in a bowl so their forms are truncated by the bowl's edge. Or, an apple can be cut in half or sections or partially peeled to create interesting variations on the basic shape. An apple's spherical shape also lends itself well to creating a strong illusion of volume by contrasting highlight and deep shadows.

It's challenging to arrange a sound composition using only two apples. This composition works because the stem area of the left-hand apple presents a different aspect of the form from the apple on the right, and the overlap creates visual unity. The backdrop is brown kraft paper draped over a shelf and up a wall.

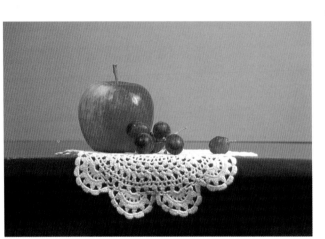

Contrasting the apple's circular shape against the smaller grapes creates compositional unity through repetition. The white of the doily creates a strong contrast of both color and value with the apple, while the doily's lower edges repeat the motif of rounded forms.

Here rounded forms of two apples are nicely contrasted against the intricate edges of Battenberg lace. The apple shapes against the white lace create a crisp color contrast and a lighter feel overall. The red of the apples is echoed in the dusty mauve background (upper right) and in the reddish brown of the shelf.

I chose to paint this composition. The apple's rounded shape nicely contrasts against the smaller, rounded grapes. The organic fruit forms also contrast with the linear shelf and the truncated triangle formed by the linen in the foreground. The creamy white linen provides a pleasing color and value contrast with the apple and grapes.

Step 1: Masking and First Wash

On a 7½″ × 10″ (19cm × 25cm) piece of Arches 300-lb. (638gsm) cold-pressed watercolor paper, I enlarged the image with a slide projector, drawing it onto the paper with a 5H pencil. I wanted the shelf to appear at both sides of the composition, but when it was in the proper position, the apple was too far left. To correct that, I drew the outline of the shelf and linen first, then moved the paper left ½″ (1.25cm) to bring the fruit toward the center of the image.

To begin, apply a ½″ (1.25cm) wide strip of masking fluid along the left and right edges of the linen. After it dries, apply a second coat and let it dry. Prewet the lower left and right corners, and apply a wash of Burnt Sienna. Quickly dry the wash with a hair dryer, then apply a dark wash of Burnt Umber and Charcoal Gray to the shadowed area just below the shelf (left and right).

Step 2: Shelf and Linen

Using a no. 4 round and a dark mixture of Burnt Umber and Charcoal Gray, apply dark lines of wood grain over the initial Burnt Sienna wash on the shelf front. Next, use a ½-inch (1.25cm) flat brush and a very dark mix of Burnt Umber and Charcoal Gray to restate the deepest shadows just below the shelf, grading the wash toward the bottom by adding more water with each stroke.

Dry the wash thoroughly with a hair dryer, then remove the masking and prewet the entire linen area. With a 1-inch (2.5cm) flat brush lay in a dilute mixture of Raw Sienna, Sepia and Cadmium Orange at the bottom center of the paper and in both the upper right and left corners. To indicate folds in the fabric, use the 1-inch (2.5cm) flat to lay a darker line on the shadow side of each fold. Next, rinse the brush in clean water, blot the brush with a paper towel and use the damp hairs to lift color from the highlight side of each fold. As the sheen begins to disappear from the paper, return with slightly darker washes to indicate the shadowed fold to the right of the grapes and the darker shadowed fold to the left of the apple.

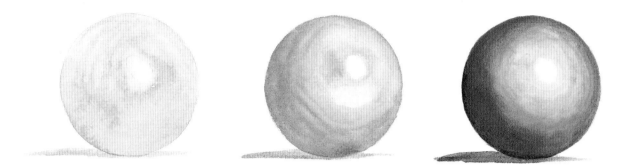

Painting a Basic Sphere

Since an apple is basically a variation of a sphere, it's quite simple to create a credible illusion of volume as follows:

1. Wet the entire shape with clean water, then wash in a base color, leaving the highlight unpainted.
2. While the initial wash is still wet, add a deeper hue of the basic color to the side opposite the highlight (the shadow side). Carry it all around the perimeter and grade toward the highlight.
3. Still working wet, add a darker hue to the shadow side. Carry a slight tint of it all around the perimeter and grade it toward the highlight.

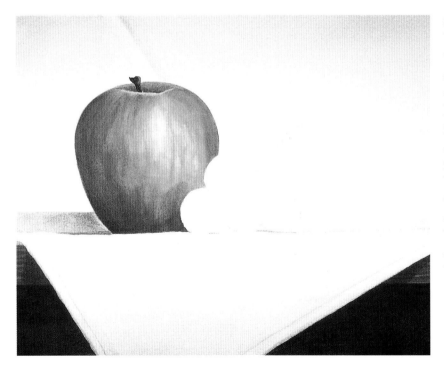

Step 3: The Apple

Wet the entire apple with clean water. Use a no. 8 round to apply a wash of Cadmium Orange, carefully preserving the highlight. Next, add washes of Vermilion Hue to the shadow side and around the entire perimeter, followed by Burnt Sienna, Burnt Umber and a deep shadow mixture of Burnt Umber and Charcoal Gray. Complete the apple by rendering the stem with a no. 4 round and mixtures of Burnt Umber and Charcoal Gray.

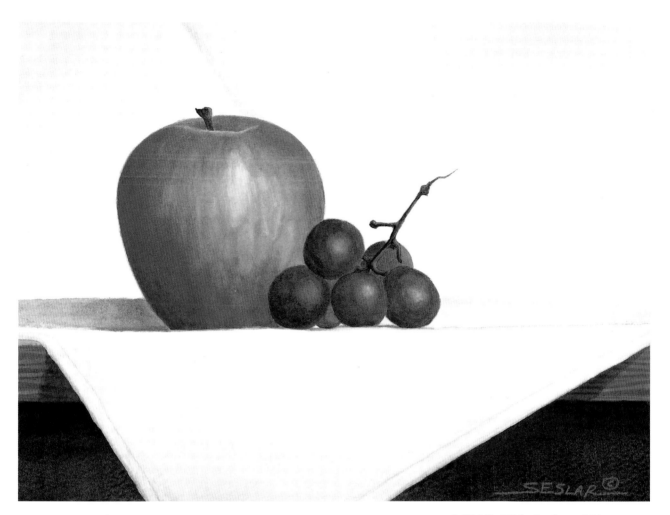

Step 4: Completing the Painting

The grapes are trickier due to their smaller size, but the procedure is the same as for any spherical form. Use a no. 4 round brush to apply mixtures of Alizarin Crimson, Ultramarine Blue and Burnt Sienna to each grape. It may take several washes to darken the color to the proper value. For the deepest darks on the grapes, add Charcoal Gray to the preceding mixture. To complete the painting, add the grape stems with a no. 4 round brush using mixtures of Burnt Umber and Charcoal Gray. Paint highlights on the stems with a mixture of Permanent White gouache, Cadmium Orange and Burnt Sienna.

Still Life With Apple and Linen
Watercolor
7½″ × 10″ (19cm × 25cm)

Demonstration 6: Cherries and Silver Creamer

Silver, brass and chrome are perfect candidates for painting from photographic references because reflections of nearby objects are complex and often distorted. If your drawing skills are still developing, it's sometimes hard to draw these unusual shapes freehand. Tracing the outlines of each reflected shape allows you to concentrate on values and colors and how they change within each shape.

The easiest way to paint silver or other reflective surfaces is to stop thinking of them as silver or anything else. If you simply paint the color and value changes you see within each shape without thinking what they are, at some point a kind of magic happens. Suddenly, almost without effort, a realistic reflective surface emerges. In this demonstration, I've provided more in-progress steps so you can see how the reflective surface of the silver creamer begins—looking quite unpromising—and then suddenly pops out looking incredibly lifelike.

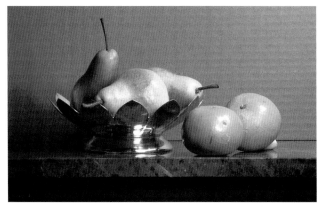

When you combine reflective surfaces like silver with interesting colors and shapes you have a great start for a painting project. For complex subjects such as this, photographic references (slides or prints) greatly simplify drawing shapes accurately.

Differently shaped silver pieces create different reflections. Try placing several silver pieces in the same setting one after the other to see which reflections are most interesting. Notice how beautifully the rich darks in the spout of this sauceboat contrast against the light shapes of the grapes. Notice also how the base of the sauceboat is reflected in the bottom of the sauceboat itself. When this happens, I usually exercise artistic license and ignore the reflected image of the base. The result is an image that, although not completely literal, is less confusing and "reads" more easily.

In this photograph the backdrop is a piece of cardboard and the shelf is a small wooden table. My two photofloods are reflected in the creamer—of course, you'd tone them down considerably. Notice how the straight edge of the table/shelf appears curved in the reflection. Notice also that it's the shadow side of the orange wedge reflected in the creamer—as a result, the reflected orange wedge is dark except across the top where light spills over from the front.

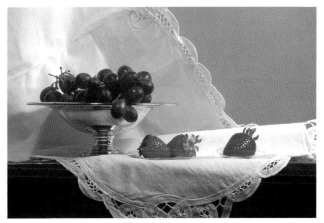

Here the cherries add color and the details of the doily make the reflection incredibly strong. As with the sauceboat, however, the central area of the bowl forms a kind of "black hole" that doesn't make much sense if you paint it literally. Again, use your artistic license and ignore it. The result will be much more believable.

This interesting combination of shapes, textures and colors could make a great painting. If you create a setup like this, a slide will give you the brightest and sharpest image to draw from. The reflections in this silver compote are subtle, so you'll need to pay close attention to value changes to create a credible illusion of the reflections.

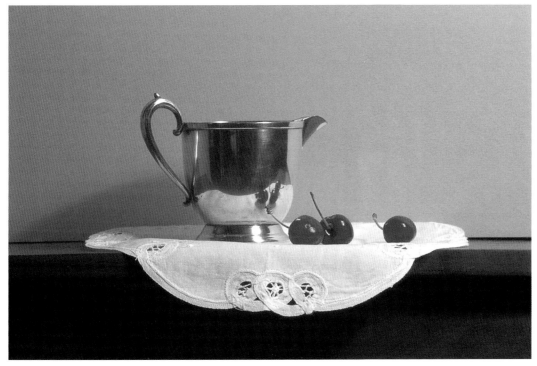

I chose this photograph because the reflections are fairly straightforward and the doily is reasonably simple to draw and paint. Keep in mind that the reflection illusion is convincing because the values are as light and as dark as they should be. If the illusion in your painting doesn't seem strong enough, try darkening your darkest values. Remember that the color of silver is largely that of the things around it—in this case, the shelf, doily, cherries, dark background (center of reflection) and light background (left and right sides of reflection).

Step 1: Drawing

After projecting and drawing this image on a 7½"×10" (19cm×25cm) piece of Arches 300-lb. (638gsm) cold-pressed watercolor paper, I used a drafting curve template to clean up the many contours in the drawing. Another good idea is to lay tracing paper over your drawing, mark the vertical centerline, then trace one half of the object. To make sure your drawing is symmetrical, flip the tracing over and realign the vertical centerline to see if it matches the profile of the opposite side. If not, use the tracing to mark the correct shape before proceeding.

Step 2: Masking

When trying to protect a large area of white paper, it's sometimes easier to mask around the outline in a strip about ⅜" (1cm) wide. This saves time, masking fluid and wear and tear on the surface of the paper. Remember to apply two coats, and let it dry after each coat.

Step 3: First Washes

Prewet the entire background above the doily, carefully avoiding the silver cup. Then, use a 1-inch (2.5cm) flat to apply a variegated wash of New Gamboge and Alizarin Crimson. At the left and along the bottom of the wash, darken the color with a hint of Winsor Green. Below the shelf, establish the overall color with several washes of Burnt Sienna, French Ultramarine and Alizarin Crimson. Let dry.

Step 4: Shadow and Wood Grain

Paint the dark shadows below the shelf using a 1-inch (2.5cm) flat and dark mixtures of Charcoal Gray and Burnt Sienna. When the first wash dries, go over it again to darken the value further. Next, using the same color mixture and a no. 4 round brush, paint the dark grain on the shelf face. Use your imagination here—there's no right or wrong. Paint the cast shadow of the silver cup (left) using the darker mixture from the background. Then paint the cast shadows of the doily on the front of the shelf using the dark mixture you used below the shelf. When everything is dry, remove the masking.

Step 5: Linen and Silver Washes

Prewet the entire doily area and lay in a pale wash of Sepia, Cadmium Orange and Raw Sienna, grading the wash from dark to light, top to bottom. Next, lay in the initial reflection colors on the silver creamer. For the spout, use the colors already used on the shelf face and the shadow below. For the light area just to the left of the spout, use the background color; for the comparable area on the left side, use the darker version of the same color. To paint the ends of the table that are reflected below the areas just painted, use the colors from the shelf. For the large dark area in the center of the creamer, use a mix of Burnt Umber, Charcoal Gray and French Ultramarine.

Step 6: Silver Details

With the same mixtures used for the doily, wash in its reflection at the creamer's base. With a no. 4 round, subtly grade the wash from darker at left and bottom to lighter at the top. Carry the creamer's handle to a high degree of finish using a no. 4 round and mixtures of the basic silver color (Burnt Umber, Charcoal Gray and French Ultramarine). Begin with pale washes, avoiding the highlight areas, then follow with darker applications of color using drybrush techniques. As you progress, make adjustments to strengthen the illusion of reflection. This means darkening the reflection of the background color on the cup's left side and the comparable color on the base. It also means darkening the darks in the base to bring out the highlight there. See if you can spot any other adjustments.

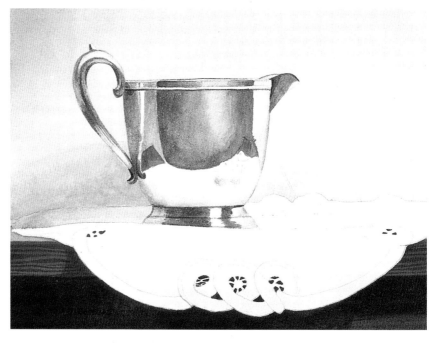

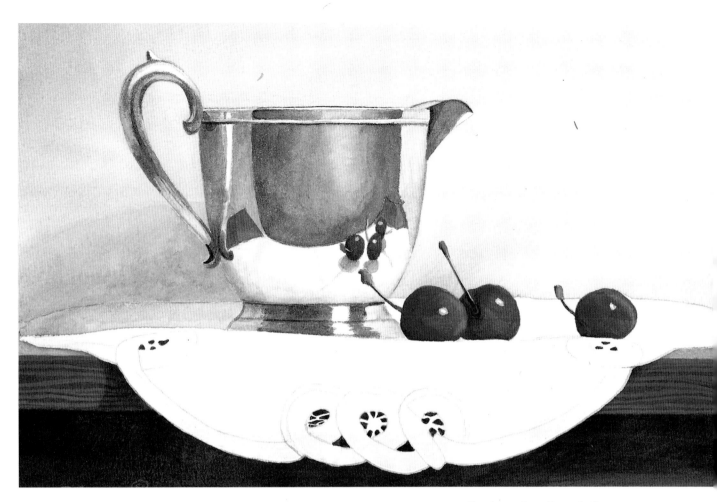

Step 7: Finishing the Cherries

To complete the painting, apply dots of masking fluid to the highlights on the cherries and their reflections. Then, apply repeated washes of Alizarin Crimson and Cadmium Red Medium. For the darker values on the left side and bottom of the cherries, add Burnt Sienna and a hint of Charcoal Gray. After removing the masking from the cherry highlights, paint the stems with mixtures of Sap Green and Burnt Umber. Highlight their right edges using a mixture of Permanent White gouache and Cadmium Yellow Pale. Paint the upper ends of the stems with a wash of Cadmium Orange, then darken the shadow sides with Burnt Umber. Voilà—reflections!

Still Life With Reflected Cherries
Watercolor
7½″ × 10″ (19cm × 25cm)

Demonstration 7: A Winter Landscape

If you live in snow country, winter is a great time to paint. The temptations of summer are buried beneath a blanket of white, and the studio is a warm, cozy place to spend a few quiet hours painting. You could look out onto an expanse of white and paint summer scenes from your photo-sketchbook, but you might want to try your hand at winter landscapes. They offer a refreshing change of pace as well as a whole different range of colors.

Lin and I are "snowbirds," spending our summers in the western United States and our winters in sunny Florida, so collecting snow scene reference has been something of a challenge. If you have a similar problem, get in touch with friends or relatives in snow country and ask them to send you promising snapshots to work from. That's what we did! The reference photographs for these winter scenes were loaned to us by Luke Buck, a talented artist and friend from the wintry state of Indiana.

Photographs like these might make interesting small paintings on their own. At the very least, they provide good reference for a heavy snowfall on trees and branches.
PHOTOGRAPHS BY LUKE BUCK

Even good reference photographs such as these can often be improved by combining them to create new and interesting compositions. In this version, note how the stream bank near the center of the image lines up with the corresponding bank in the barn photograph. The hillside in the upper right corner of the stream photograph slopes toward the barn, giving the impression of a farm nestled at the base of rolling hills with a meandering stream nearby.
PHOTOGRAPHS BY LUKE BUCK

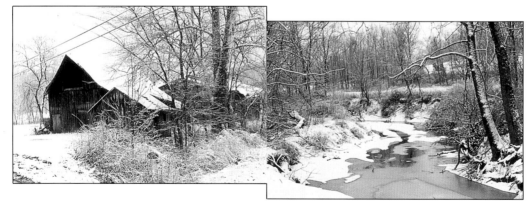

This second version may be even nicer. Here the horizontal bands of white snow at the base of the tree line in each photograph are aligned. You'd probably want to eliminate the large trees near the center of the stream photograph, but other than needing a little simplification, it's a very promising composition.
PHOTOGRAPHS BY LUKE BUCK

Here are two reference photographs that can be improved by combining.

PHOTOGRAPHS BY LUKE BUCK

Lin decided to overlap the two photographs so the line formed by the snow and distant tree line (left) would line up with the snow line at the base of the house (right). To improve the composition further, she eliminated the two trees near the center of the left-hand photograph and the telephone pole at the extreme right in the house photograph. Finally, she extended the distant tree line from the left photograph behind the house in the right photograph.

PHOTOGRAPHS BY LUKE BUCK

If the difference in color between two photographs makes it difficult for you to see the composition, try photocopying the taped-together photographs. The black-and-white version makes it easier to see the value structure of the composition and to visualize the effects of any changes.

Step 1: Drawing and First Washes

Since Lin liked the proportion resulting from the two photographic prints, she simply measured the height and width, then scaled up to a larger piece of watercolor paper. In this case, from a 4″×10½″ (10cm×27cm) photo-montage to a 6″×16″ (15cm×41cm) piece of Arches 300-lb. (638gsm) cold-pressed watercolor paper. Using an opaque projector, she traced the desired elements from each photograph. Copy her beginning painting here, masking the white snow atop the roof and porches of the house.

When the masking is dry, prewet the sky with clean water, then apply a variegated wash of Antwerp Blue and Cerulean Blue with a 1-inch (2.5cm) flat brush. As the wet sheen begins to disappear from the paper, paint the distant tree line using mixtures of Antwerp Blue, Brown Madder and Burnt Umber. Finally, press the edge of a painting knife into the wet wash of the distant tree line to indicate dark trunks and branches (see page 53 for details of this technique).

Color Testing

You may think that experienced artists simply mix and apply the desired color as a matter of course. The truth is that most watercolorists test color mixtures on a scrap of watercolor paper to see how the color looks wet, how it dries and how it relates to colors already used in a painting. This is one of several test scraps Lin used in the course of this painting. The scrap shows two variations of the tan color used on the side of the house as well as several subtle variations of the color used for the snow and some shadows in the painting.

Step 2: Pines and Snow

As the painting progressed, Lin decided that a group of pines on the left would be more effective than the leafless trees in the reference. Paint them in with a ½-inch (1.25cm) flat brush using mixtures of Sepia and Antwerp Blue. For the snow in the foreground, prewet the area lightly with clean water, then use a 1-inch (2.5cm) flat brush to indicate shadowed areas with a dilute mixture of Antwerp Blue, Alizarin Crimson and Burnt Umber.

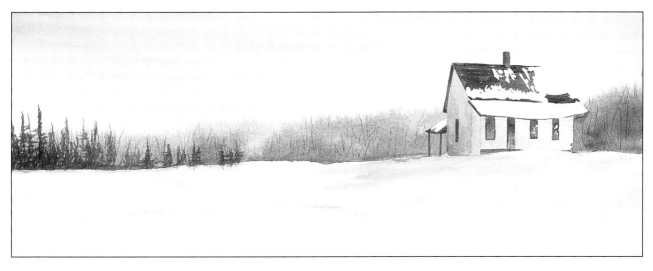

Step 3: House

Use a no. 4 round to wash the sides of the house with a mixture of Sepia and Yellow Ochre. After drying the wash with a hair dryer, apply a wash of the snow shadow mixture to the left side of the house, grading it toward the right by adding clean water with each brushstroke. When the sides are dry, paint the roof with a dark mixture of Sepia and Antwerp Blue. Paint the chimney with Brown Madder, then darken the shadow side using the snow shadow color. Finally, apply some preliminary details to the windows and doors and peel the masking from the snow areas on the roof and porches.

Step 4: Final Details

Using the snow shadow color mixture from step 2, indicate shadows on the just-unmasked snow on the roof and porches. Next, use a mixture of the snow shadow color and Permanent White gouache to paint the four porch posts and the ornamental work just below the front porch eave. Finally, with a no. 1 liner and mixtures of Sepia and Burnt Sienna, paint the posts and wire fence on the left and the tall bare tree to the right of the house.

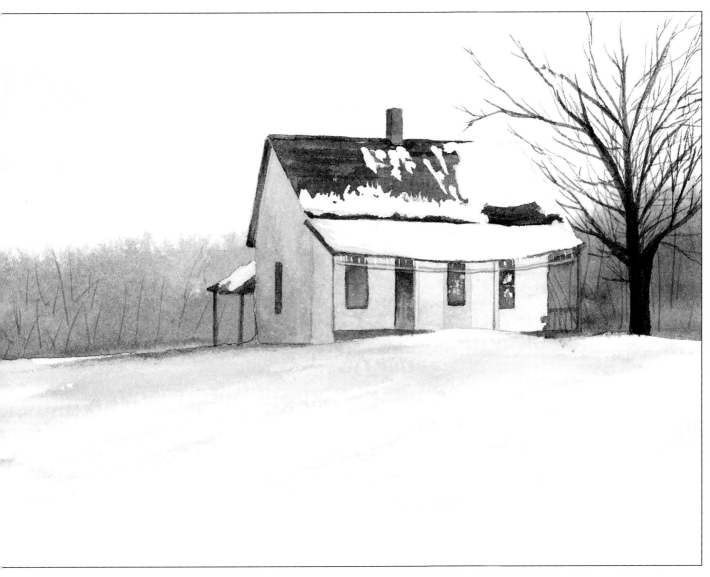

First Snow
Lin Seslar
Watercolor
6″×16″ (15cm×41cm)

Demonstration 8: A Summer Landscape—Grand Canyon

Vacations provide a wealth of opportunities to stock your photo-sketchbook with interesting summer landscape scenes. Naturally, the reference you collect reflects your artistic inclinations. Every time I pass through Iowa, for example, I know what inspired Grant Wood's paintings. I'm always drawn to the strong perspective of midwestern plowed fields or the warm tan of corn stalks just before harvest. Still, for me, the wide expanses of the West are the ultimate landscape. No matter what appeals to you, the following tips and demonstration will help you collect better reference and create stronger paintings.

This photograph was taken without using a polarizing filter on the camera lens. Notice how washed-out the sky looks.

Compare the sky in the previous photo to the sky in this one taken using a polarizing filter. Better, right? A good compromise would be to use this one for everything but the water. For that, I'd refer to the first photograph because the sky reflections on the water add color and visual variety that is lost when a polarizing filter is used.

This is an example of a marginal reference photograph. The left side is reminiscent of some Thomas Moran landscapes, but the large boulder on the right is a bust, so to speak. You might be able to save the shot by ignoring the boulder and inventing a little of the canyon in its place from another shot. Or, reconcile it to the "boneyard" for parts.

This is a good example of a fairly promising shot taken from a highway overpass in Grand Teton National Park. Eliminate the buildings from the tree line and spice up the color in the meadow, and you have the makings of a successful painting.

This is a nice shot that could be painted as is. Of course, you would inevitably make hundreds of minor changes in color and emphasis even if you attempted to paint it absolutely literally. In this case, Lin decided to use it as a basic framework for her composition, but she opted to change the time of day as a means of introducing more interesting colors.

Lin selected this photograph from her files to serve as a general guide to the richer colors she had in mind. The challenge, of course, would be to refer to the daylight scene for values and forms while using this one to stimulate color ideas.

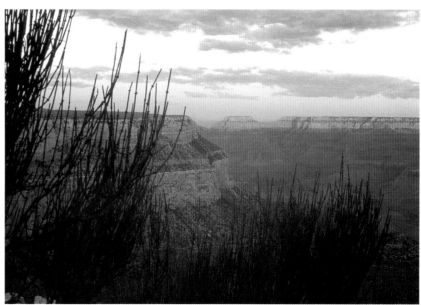

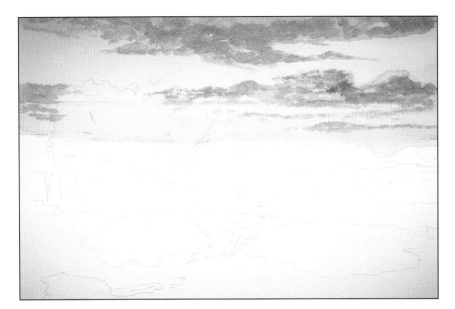

Step 1: First Washes, Clouds and Sky

For this painting, Lin selected a 10″×15″ (25cm×38cm) piece of Arches 300-lb. (638gsm) cold-pressed paper onto which she traced the key elements from her chosen photograph.

Prewet the sky with clean water. Use a 1-inch (2.5cm) flat brush to apply a pale variegated wash, beginning with mixtures of Cerulean Blue and New Gamboge at the top and transitioning into Alizarin Crimson and New Gamboge at the horizon line. When the wash is dry, return with a ½-inch (1.25cm) flat brush to indicate the shadow portion of the clouds with mixtures of Cerulean Blue and Cobalt Violet. Next, working over and slightly above the cloud shadows, add the illuminated color of the clouds with mixtures of Alizarin Crimson and New Gamboge.

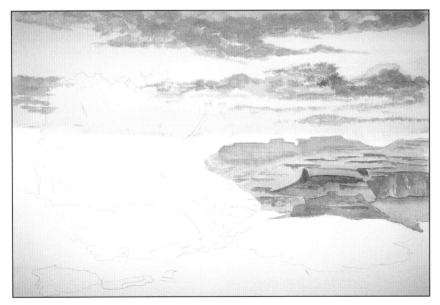

Step 2: Sunlit Rocks and Canyon Purples

With a no. 8 round brush, paint the brightly illuminated rocks just below the horizon line with Cadmium Orange. Adding clean water along the bottom edge of this wash allows the color to soften down into the deeper canyon areas. When the wash is dry, render the blue-purple shadowed rock faces deeper in the canyon with mixtures of Cerulean Blue and Cobalt Violet. Several applications of color will be required to suggest the lighter and darker rock faces within the canyon.

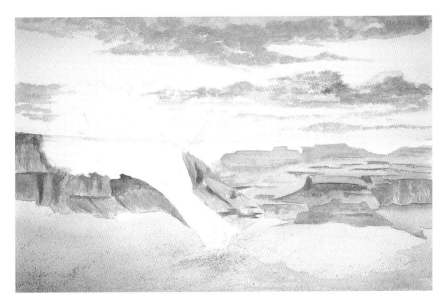

Step 3: Rocks and Foreground Wash

Still working from distance to foreground, paint the middle-ground rocks just behind the lone tree. Begin with mixtures of Alizarin Crimson and New Gamboge, then follow with shadow tone mixtures of Cerulean Blue and Cobalt Violet. Next, prewet the foreground with clean water. Apply a wash of Cadmium Yellow Pale and Cadmium Orange, working from right to left and gradually adding Alizarin Crimson to the mixture as you move left. When the wash is dry, cover the sky and canyon areas with scrap matboard. Use a fan brush to spatter the foreground with the color mixtures used to paint the middle ground.

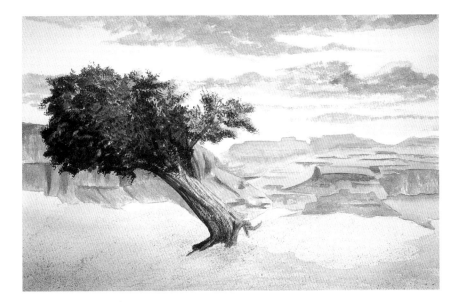

Step 4: Tree and Foliage

Working with a no. 4 round brush and mixtures of French Ultramarine, Burnt Sienna, Alizarin Crimson and New Gamboge, begin establishing the color and value of the weathered tree trunk and limbs. Several applications of color are necessary to create the darkest values. For the foliage, first apply a dilute mixture of Sap Green, Sepia and New Gamboge. As this wash dries, apply a darker mixture of Sap Green, Sepia and French Ultramarine for the main body of the foliage. A still darker mixture of the same colors establishes the deepest shadow tones in the foliage.

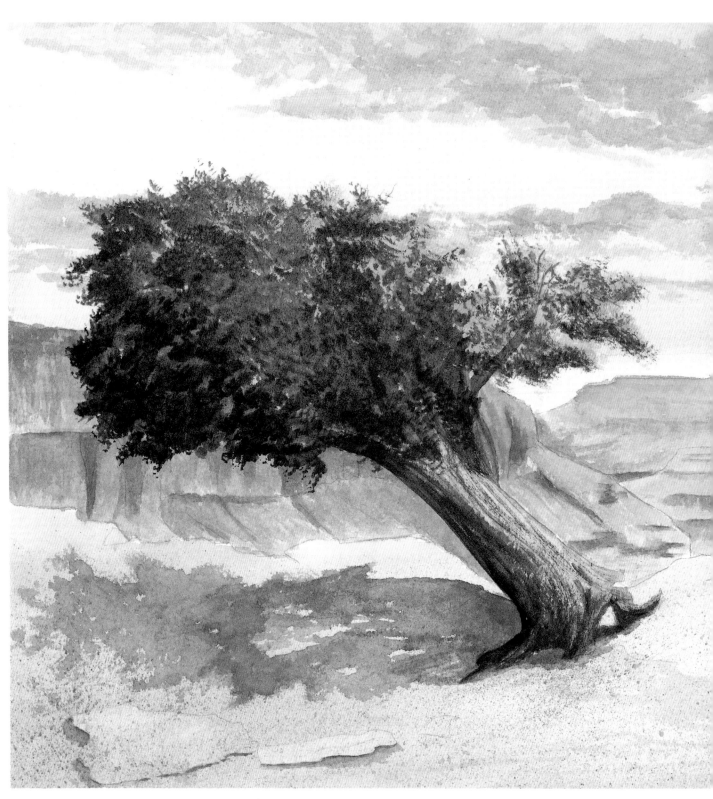

South Rim—Grand Canyon
Lin Seslar
Watercolor
10″×15″ (25cm×38cm)

Step 5: Cast Shadow and Final Touches

Add the cast shadow of the lone tree using mixtures of French Ultramarine, Alizarin Crimson and Cobalt Violet. Notice that Lin left "holes" in the shadow for interest and that the shadow has been extended to the left to indicate the sun's lower position at sunset. When the cast shadow is complete, deepen some of the values on the shadow side of the tree trunk and roots to keep everything in balance. To complete the painting, use clean water to wet the tops of the two irregular rock slabs in the lower left, then lighten the color by lifting pigment with a dry paper towel. To bring the rock slabs out, add a shadow tone around their lower edges with mixtures of Cadmium Yellow Pale, Cadmium Orange and Burnt Sienna.

Demonstration 9: A Child on the Beach

Nearly every aspiring artist has a snapshot or two of children or grandchildren playing at the beach. With a little creativity, these snapshots can be transformed into keepsakes to be hung on the wall rather than tucked away in a seldom-opened scrapbook. If available children/grandchildren snapshots aren't quite up to par, you can improve your reference by (1) waiting for the subjects to become engrossed in play before you roll out the camera; (2) using a zoom telephoto lens to get natural postures when the kids aren't aware they're being photographed; and (3) by taking lots of shots so you can combine elements or bring separate playmates together to paint as a group.

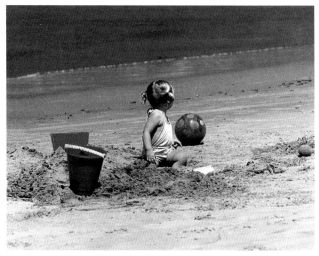

Here's a good basic reference photograph of a child at play on the beach. It's good because the face of the child is hidden, which avoids considerable frustration if portraits aren't your specialty. The photograph has a good play of strong light and shadow and a suggestion of other elements you can combine for a strong composition—beach pails, sand, water and waves. On the minus side, the water is boring, the balls and buckets are randomly placed (poor composition) and the child is obviously looking at something of interest (what?) in the distance.

The child's posture indicates she is intent on something to her right, so Lin placed her on the extreme left to allow room for that "something" of interest. Lin felt a flying seagull would be just the sort of thing that would enthrall a small child. Lin chose this photograph and selected the seagull on the right as the more interesting shape. She projected the seagull's image and traced it onto the watercolor paper after adjusting the image size and position.

Lin searched her photo archives and found a photograph with reasonably interesting wave action. By eliminating the wave in the background and lowering the horizon line she created a solid compositional framework for all that followed. Projecting the wave onto a 10" × 15" (25cm × 38cm) piece of Arches 300-lb. (638gsm) cold-pressed watercolor paper, she drew the outline of the wave, rolling foam and horizon line.

Next, Lin projected the image of the child onto the same sheet of watercolor paper. By moving the projector closer or farther away, left or right, Lin tried and discarded a variety of possible compositions. When she found one she liked, she traced the outline of the child in the desired position.

Lin decided to drop the two balls from the photo of the child. She liked the sand pails but felt the placement, size and color were wrong for what she had in mind. Returning to her photo archives, she retrieved three photographs of similar sand buckets in different positions. She eliminated this bucket for three reasons: Its color was wrong, the upright position was static and the lighting was opposite that of her main reference.

The color and orientation of this bucket were promising. The cast shadow was in the wrong direction, but the lighting inside the bucket was intriguing. Still, it wasn't quite right for the composition.

The bucket in this photograph had all the desired qualities—an interesting orientation, good color and a cast shadow positioned similarly to the one in the reference photo of the child. Satisfied that this was the best choice, Lin projected the image and chose the lower right corner as the most desirable position compositionally. The bucket's opening guides the viewer's eye toward the child; the child's gaze takes the viewer's eye to the seagull and from there back to the bucket.

Step 1: Masking
With the major elements drawn on your watercolor paper, apply two coats of gray masking fluid to the shapes of the child, the seagull and the bucket.

Step 2: Sky and Background Water
Prewet the sky with clean water and apply a variegated wash of Cerulean Blue, Cobalt Violet and Alizarin Crimson using a 1-inch (2.5cm) flat brush. When the sky is dry, use a ½-inch (1.25cm) flat brush to paint the background water on dry paper using a mixture of Cerulean Blue, Winsor Blue, Winsor Green and Burnt Sienna. Leave streaks of paper unpainted to suggest distant whitecaps.

Step 3: Wave and Sand

When the background water is dry, paint the illuminated portion of the wave using a ½-inch (1.25cm) flat brush and a dilute mixture of Viridian, Alizarin Crimson and Cadmium Yellow Pale. Then, with the same brush, quickly paint the rolling water visible above the foam. As the wave begins to dry, deepen the color at its base using a mixture of Viridian and Alizarin Crimson. Finally, with a wet brush, wash a dilute mixture of the sky color along the base of the wave.

When the wave area is dry, prewet the entire sand area and paint it using variegated washes of Burnt Umber and Payne's Gray applied with a 1-inch (2.5cm) flat brush. When the initial wash is dry, cover the sky and wave with scrap matboard, then lightly spatter a sand texture using a fan brush and the color mixture from the variegated sand wash. When the first spatters are dry, move the matboard to cover all but the lower left corner and bottom edge of the paper. Over this area, spatter a darker, more pronounced sand texture with a fan brush to bring the foreground forward.

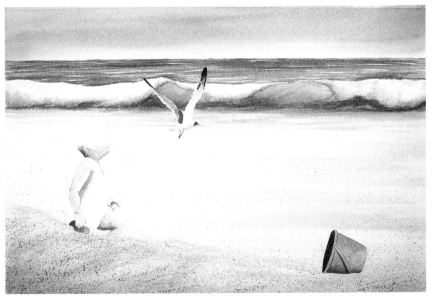

Step 4: Paint the Gull, Pail and Child

Remove the masking from the gull, pail and child. Using a no. 4 round brush and mixtures of Charcoal Gray and Cerulean Blue, paint the wings, feet and head of the flying gull. Remask the handle of the bucket, and apply a flat wash of Cerulean Blue. As it dries, use the seagull mixture to darken the upper and lower edges of the bucket to round out the form. Finally, paint the child's flesh tones with a no. 4 brush and mixtures of Cadmium Orange, Alizarin Crimson and Cobalt Blue.

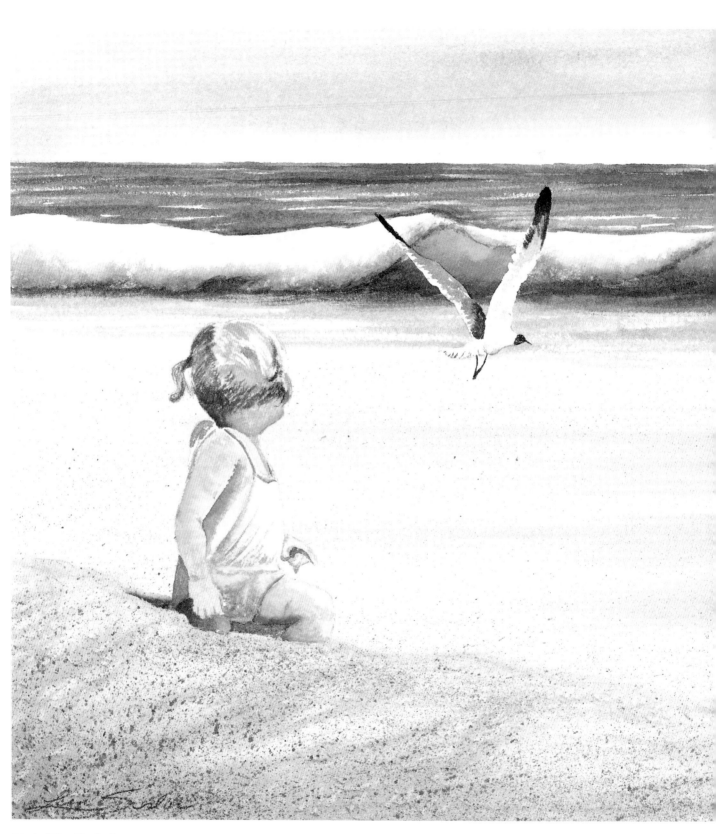

Little Miss Curiosity
Lin Seslar
Watercolor
10″ × 15″ (25cm × 38cm)

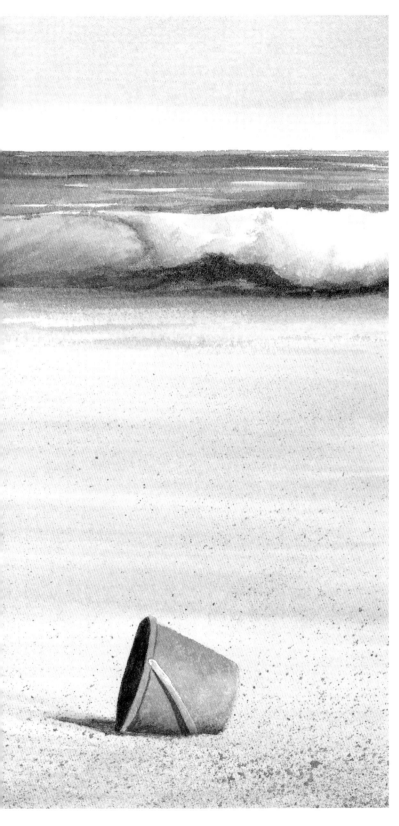

Step 5: Complete Painting

Apply a graded wash of Cerulean Blue to the child's bathing suit (darkest on left). While the wash is still wet, add Winsor Blue and darken the left side a bit more. When the wash is dry, indicate folds in the fabric with a no. 4 brush and dilute Cerulean Blue. Begin to paint the hair, using an overall wash of Cadmium Yellow Pale and Raw Sienna. As it dries, add middle tones with darker mixtures of the same colors and then the darkest darks by mixing in some Warm Sepia. Remove the masking from the handle of the bucket, and detail it with dilute mixtures of Cerulean Blue and Charcoal Gray.

Demonstration 10: Rolling Surf

Photographic reference is a godsend for subjects like the ocean that just won't stand still. A zoom telephoto lens and ASA 400 speed film will help you stop the action. Even so, you'll need to shoot more film to get good shots, and frequently you'll have to combine elements from several shots to create a good composition—a wave from one, a beach from another and birds from yet another. Finally, when it comes to rendering moving water, you may find that adopting an impressionistic style will help keep you sane and keep your paintings from looking stiff or overworked.

This wave is quite interesting, but the beach is boring, as are the sky and background water. I'll keep this one in my archives to scavenge for parts. The wave could be transplanted to a composition that lacks dramatic motion, and the colors might serve as a guide in another painting.

This one offers many possibilities. For example, it could be improved by cropping from the top and the left side. Or, you might crop part of the sky to create a long, "skinny" twilight seascape. Another option would be to crop from both the left and right for a dramatic vertical composition. Why not grab a couple of matboard scraps and try these cropping variations for yourself?

Lin really liked the wave in this reference photograph but wasn't especially fond of the awkward shape formed by the two overlapping headlands or of the expanse of uninteresting foam in the foreground. Nevertheless, she decided to use this image from the horizon line down as a starting point for her composition.

Lin liked the misty distant headlands on the right side of this photo and thought she might be able to use them as a general guide for her composition. The beach, although lacking merit, did suggest a solution for the excess of foreground foam in the previous reference. Lin decided to add an area of exposed beach in the lower right corner of the composition.

Step 1: Drawing, Masking and Painting the Sky and Distant Headland

For this composition, Lin taped a 12″×16″ (30cm×41cm) piece of Arches 300-lb. (638gsm) cold-pressed paper to a drawing board. While projecting the first slide, she drew the horizon line and the outline and details of the waves. Next, she projected the second slide and positioned it so its horizon line aligned with the one she'd drawn. She then drew the approximate shapes of the two receding distant headlands.

Copy her beginning drawing, then mask the foam on the two waves, the "foamlets" and the foreground in general. When the masking is dry, prewet the sky with clean water and create cloud forms with varied mixtures of Cobalt Blue, Cobalt Violet and Winsor Blue. As the wet sheen begins to leave the sky, use a 1-inch (2.5cm) flat brush to wet the most distant headland with clean water, then apply a wash mixed from the sky colors plus Alizarin Crimson and Sepia.

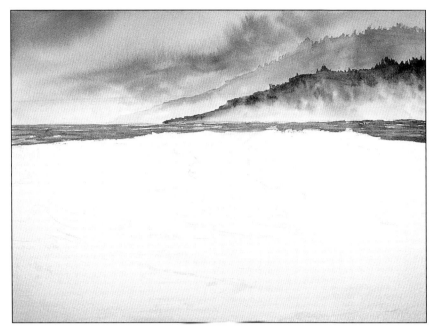

Step 2: Tree-Covered Headland and Background Water

When the sky and distant headland are dry, use a 1-inch (2.5cm) flat brush to wet the closer headland with clean water. With the same brush, add Warm Sepia and New Gamboge to the sky mixture and paint the tree-covered headland. Beginning at the top of the headland, allow the dark green mixture to migrate toward the bottom to create the effect of a low fog or mist just above the water's surface. Drop a very dilute mixture of the sky color into the base of the headland to give the fog a little color. Paint the distant water just below the horizon line using the sky mixture plus Payne's Gray and Winsor Green. Leave small streaks of the paper unpainted to suggest distant whitecaps.

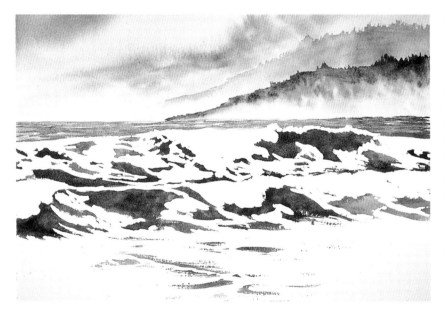

Step 3: Water

To paint the bulk of the water area, begin with the basic sky mixture (Cobalt Blue, Cobalt Violet, Winsor Blue) modified by adding Winsor Green and Payne's Gray. Without prewetting, use a ½-inch (1.25cm) flat brush to paint the deep green of the wave faces and the surrounding water. After the water area dries, remove the dried masking fluid to reveal the white paper that will become the rolling water and foam.

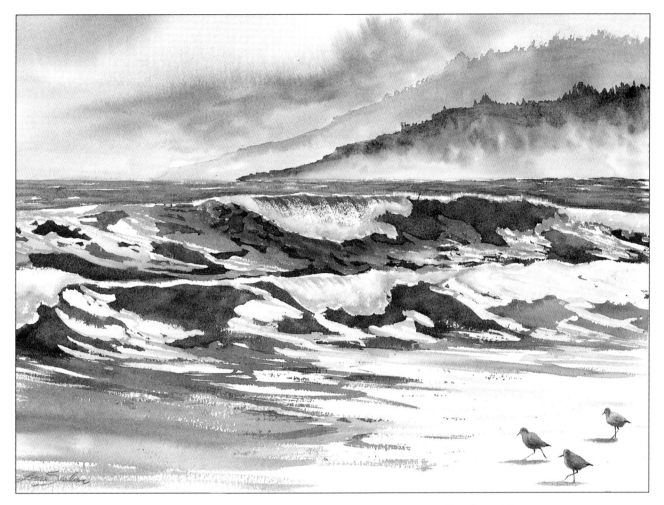

Step 4: Final Steps

With the color mixture for the water from the previous step and a ½-inch (1.25cm) flat brush, use a drybrush stroke to paint the rolling water (center) on each of the waves. Next, using a no. 8 round brush and a dilute wash of Payne's Gray, Alizarin Crimson and Cobalt Violet, paint the shadowed foam at the base of each roll and on the face of each of the waves. Darkening the mixture, paint the more deeply shadowed foam directly beneath the rolling water in the upper wave (center).

To complete the painting, use more of the basic water color mixture to paint moving water in the lower left corner. Leave the lower right unpainted to suggest a bright exposed beach.

The sandpipers were a last-minute addition. With no reference photograph close at hand, Lin referred to *The Audubon Society Field Guide to North American Birds—Western Region* (Udvardy, 1977) for general shape and coloration, then sketched the birds freehand. After quickly painting them with mixtures of Burnt Umber, Payne's Gray and Cobalt Blue, she added shadows at their feet with the mixture used for the foam shadows in the previous step.

Breakers Ashore
Lin Seslar
Watercolor
12″×16″ (30cm×41cm)

Demonstration 11: Cape Hatteras Lighthouse

Almost anyone who has ever gone on vacation has at least a few snapshots of lighthouses. In fact, many people collect lighthouse memorabilia (including paintings). With the feeling of nostalgia they evoke and their usually unspoiled natural surroundings, lighthouses make great subjects. They come in a great variety of shapes, sizes and colors. Some, like Owl's Head in Maine, are short and compact while others, like Cape Hatteras, are tall and stately. Some lighthouses are plain and functional while others are decorated with barber pole stripes, interlocking diamonds or alternating bands of color. Despite their interesting decoration, lighthouses pose some interesting compositional challenges. Let's look at a few examples.

As with the previous photo, this was the only possible vantage point for a reference photograph. It has a number of problems. The upward angle is too great to work well in a painting, the subject is nearly centered in the image and the small symmetrical building at its base is boring. However, the foliage is interesting and the dirt path has a nice sweep to it. To paint this lighthouse, I'd use another lighthouse shot with a more acceptable perspective and transplant the red bands in the appropriate places. If I kept the utility building, I'd choose an angle with a partial view of the side and roof. A freehand drawing might be the best solution.

This is a good example of one of the problems with lighthouses—it's often difficult to find a good paintable angle. This upward view contrasts the white tower nicely against the deep blue sky, but the angle is so severe it would be difficult to create a pleasing painting from it. Note the man to the left of the tower taking a picture. His would be the ideal perspective, but at such close range, the lens can't get the whole tower into one frame. If you are determined to paint a lighthouse in a situation such as this, you'll probably need to take a series of shots and use them as the basis for a freehand drawing.

This is a wonderful lighthouse in a wonderful setting. I scrambled around the boulders on both sides of the lighthouse, and nearly every photograph had potential as a painting. This photograph could serve as the basis for a painting as is, but you might try cropping the bottom third and the top quarter to change from a vertical to horizontal format. Doing so would place more emphasis on the water and lighthouse than on the rocks. As an alternative, cropping on all sides would emphasize the lush trees surrounding the lighthouse.

Lin chose this reference slide because it had obvious potential but could benefit from judicious cropping. She quickly decided the composition could benefit from less foreground and less sky. Naturally, the height of the lighthouse limited how much sky could be cropped. To make what remained interesting, she planned to use a variegated wash and lift out wet paint with a wadded paper towel to suggest soft cloud forms.

Step 1: Sky and Masked Lighthouse

For this painting, Lin selected a piece of 8″×16″ (20cm×41cm) Arches 300-lb. (638gsm) hot-pressed paper. After taping the edges to a drawing board, she projected the reference slide and moved the projector closer until the image matched the cropped version she'd settled on earlier.

With a simple outline of lighthouse, horizon line and dune on your paper, mask the lighthouse with two coats of gray masking fluid, leaving the window area at the top of the lighthouse unmasked so the sky will show through.

Prewet the sky with clean water, and use a 1-inch (2.5cm) flat brush to apply various mixtures of Cerulean Blue and Cobalt Blue. As you near the horizon, add Alizarin Crimson to the mixture. As the wet sheen begins to disappear from the paper, daub the wash with a crumpled paper towel to lift out soft cloud shapes.

Step 2: Background Water

Paint the background water and small wave using a ½-inch (1.25cm) flat brush and mixtures of Winsor Blue, Winsor Green and Payne's Gray over dry paper. Leave small streaks unpainted to suggest distant whitecaps. For the wave, add more Winsor Green to the mixture; leave an area unpainted to suggest rolling foam. Use the sky mixture from the previous step to paint the water and the reflections on the beach.

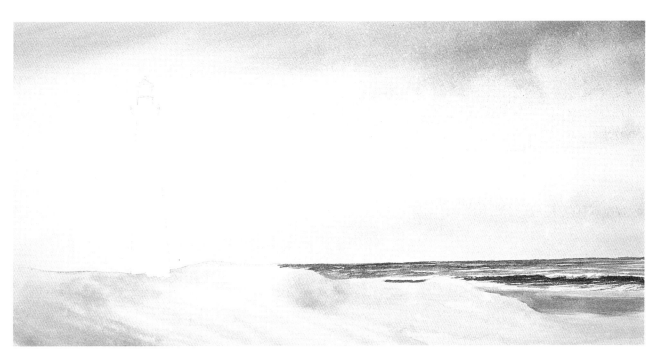

Step 3: Dune and Beach

Working with a 1-inch (2.5cm) flat brush, wash in the dune using dilute mixtures of Burnt Umber, Cobalt Blue, Yellow Ochre and Burnt Sienna. To suggest shadows, add Cobalt Violet to the mixture. Remove the masking from the lighthouse in preparation for the next step.

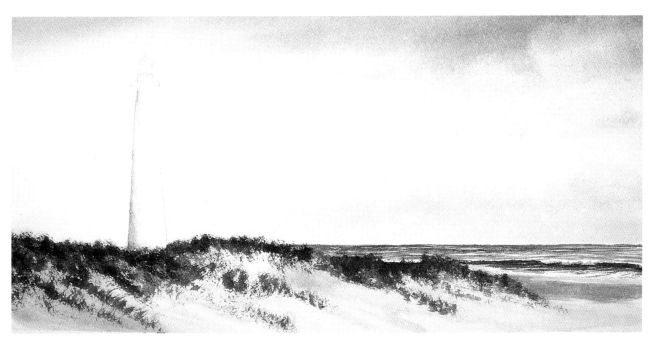

Step 4: Dune Grass and Shadow

Lay a piece of scrap matboard over the sky to protect it from accidental splatters, then paint the green dune grasses using a small fan brush and mixtures of Sap Green, Cobalt Blue, Sepia and Alizarin Crimson. Prewet the shape of the tower and use a no. 4 round to apply a wash of Burnt Sienna, Ultramarine Blue and Cobalt Violet along the left side to suggest shadows.

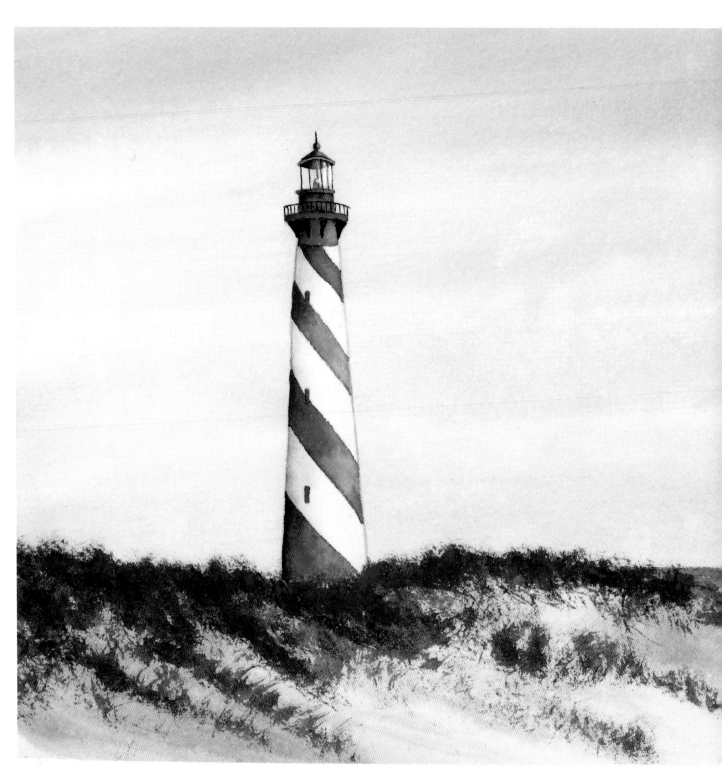

Step 5: Final Steps

Using a no. 4 round, paint each of the black barber-pole stripes on the tower with washes of Charcoal Gray. Then, with a no. 1 liner, paint the fine details of the structures at the top of the tower (railing, window frames, etc.). Paint the light inside the tower with fairly pure Yellow Ochre, then highlight the right side with a mixture of Cadmium Yellow Pale and Permanent White gouache. Give the window panes on the right side of the tower a pale wash of dilute Permanent White gouache to suggest reflections. With a no. 4 round, add hints of red and blue-purple flowers among the grasses using various mixtures of Cobalt Violet, Alizarin Crimson and Permanent White gouache.

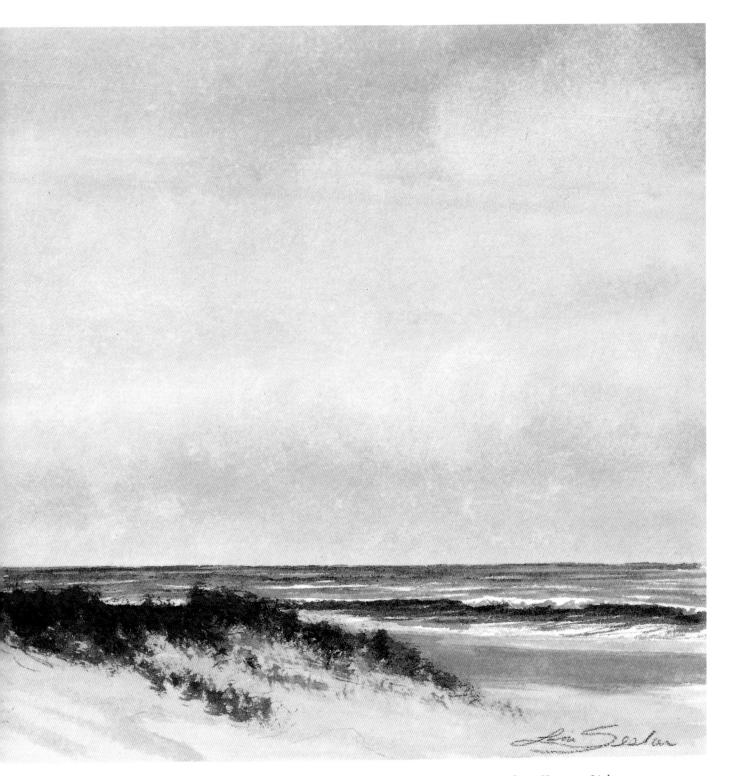

Cape Hatteras Light
Lin Seslar
Watercolor
8″×16″ (20cm×41cm)

Demonstration 12: Mackinac Island Tulips

Backyard Close-Ups

If you're ever in need of interesting subjects to fill your photo-sketchbook, a good place to begin is in your own backyard or a neighbor's. The photographs shown here aren't literally from my back-yard but they are typical of what can easily be found and transformed into interesting paintings. Let's see what we have.

This scene is typical of many backyards. As you add to your photo sketchbook, try shooting the same elements from different angles and at different times of day. Be alert for interesting shadows and color juxtapositions. Don't hesitate to use artistic license. Wouldn't this scene have more character if a doll or worn teddy bear were propped against the wheel of the wagon or perched inside as though about to be taken for a ride by an unseen playmate?

At first glance, you might dismiss a backyard scene as humble as this—but don't. The colors are rather lack-luster, but that's why you were granted artistic license! If the composition seems unfocused, try cropping away the debris, like the side wall at the extreme right. While you're at it, crop off the left wall as well. Take a hard look at the anorexic plants on the porch. You could eliminate them or give them a shot of artistic fertilizer to make them lush green with some colorful flowers.

This scene is a great example of "less is more." It was shot near sunset to pick up the wonderful warm colors and shadows to complement the rich colors of the bougainvillea blossoms. In a painting, I would accentuate the colors of the blossoms and change the cast shadow into a more lively blue-purple shade. A gravel texture spattered in the foreground would provide a nice contrast to the smoother texture of the concrete block wall.

This scene has potential but needs "doctoring." I'd crop most of the dark shadows from the right to create a more square composition. I'd also make the remaining shadows in the background much more colorful with washes of loosely mixed muted blue and red-purples. Eliminate the distracting grasslike leaves sprouting out of the pot, and make the flowers a bit more lush and colorful. The peeling paint is a wonderful textural contrast and gives the image character.

This loveable little fellow could be a painting just as he is, but he (or she?) would make a great addition to any of the preceding photographs. Adding a little life, such as a bird, a cat or a squirrel, can bring an otherwise marginal image to life.

Lin selected this scene for the demonstration but decided to crop the top quarter of the image to focus better on the yellow blossoms. The black shutters were boring slabs of wood, so she used the shutters from the following photos to provide the necessary details.

This photograph could make a fine painting on its own, but this time its only purpose was to provide reference for the details of the shutters that Lin wanted to add to her painting.

Step 1: Masking and First Washes

After cropping the chosen photograph, Lin selected an 8″ × 8″ (20cm × 20cm) piece of Arches 300-lb. (638gsm) cold-pressed watercolor paper and traced the key details onto it with a 5H pencil.

Use liquid masking on the tulips and some of the larger leaves at their base. When the masking is dry, prewet the paper with clean water and apply a wash of Sap Green and Cobalt Violet with a 1-inch (2.5cm) flat brush. For a more dramatic image, Lin changed the house's color to a near-complement of the yellow tulips.

Step 2: Dark Window and Shutter Washes

When the initial wash is dry, use a no. 4 brush with a slightly darker mixture of the same colors to indicate shadows below each of the clapboards. Next, paint the pale shadow tones on the window frame using dilute mixtures of French Ultramarine, Burnt Sienna and Cobalt Violet. When that dries, use the shadow mixture from below the clapboards to paint the lines around the window frame. To render the shutter, wash on a mixture of French Ultramarine, Alizarin Crimson and Sap Green. Paint the dark interior of the window with the same mixture used to paint the clapboard shadows.

Step 3: Paint Grasses and Remove Masking

Using a ½-inch (1.25cm) flat brush and mixtures of Sap Green, Sepia and Cadmium Yellow Pale, wash in the grassy area below the clapboards. Over this, paint the darker mass of grasses using the same basic mixture darkened with more Sepia and Winsor Blue. After establishing the basic shape of the grasses at the base of the tulips, use a no.4 round to sweep individual blades of grass up toward the blossoms. When everything is dry, remove the dried masking.

Step 4: Blossom Wash and Shutter Detail

Using a no. 4 round and a dark mixture of French Ultramarine, Alizarin Crimson and Sap Green, indicate the slats and other details of the shutter. Then, with the same brush and mixtures of Sap Green and Cadmium Yellow Pale, wash in the yellow-green of the large leaves at the base of the flower bed. Paint the tulip stems with Sap Green, Sepia and Winsor Green. Wash the blossoms in with Cadmium Yellow Pale.

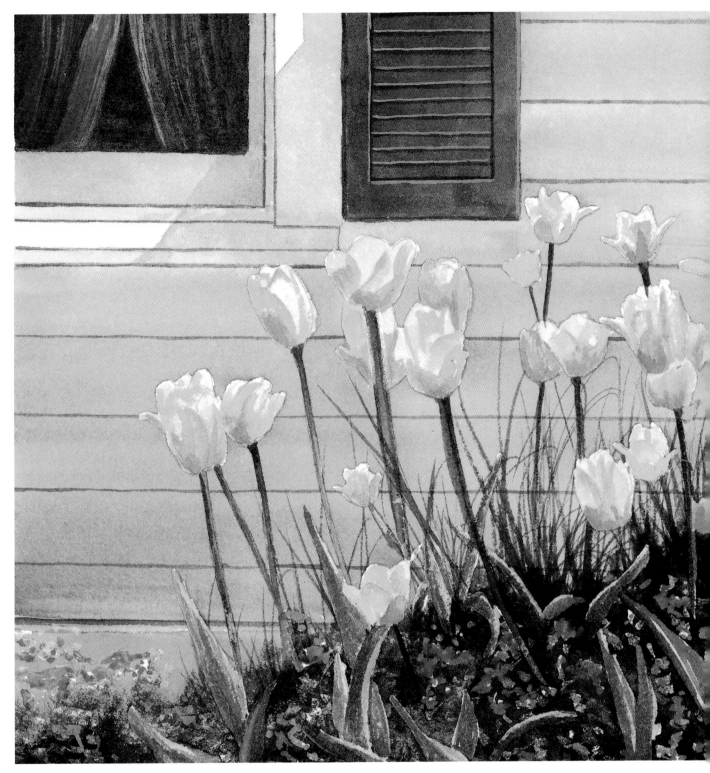

Step 5: Final Details

Darken and detail the large leaves with Winsor Green and Sepia. Then, apply a middle value to the tulip blossoms using a no. 4 round brush and a mixture of Cadmium Yellow Deep and Cadmium Orange. Paint the deepest tones using the middle tone mixture plus Burnt Sienna. Finish the flower bed area by washing Cobalt Violet over the remaining (recently unmasked) spots of white. To complete the painting, add highlights to the shutter using a mixture of Cobalt Violet and Permanent White gouache, then drybrush a suggestion of lace curtains in the window with Permanent White gouache.

Mackinac Island Tulips
Lin Seslar
Watercolor
8″ × 8″ (20cm × 20cm)

INDEX